Sept. 30, 199+

Ken,

A book by my first boss for
my best boss. Thank you
for teaching me about commitment
and integrity.

Jeanne

On the
Surface
of Things

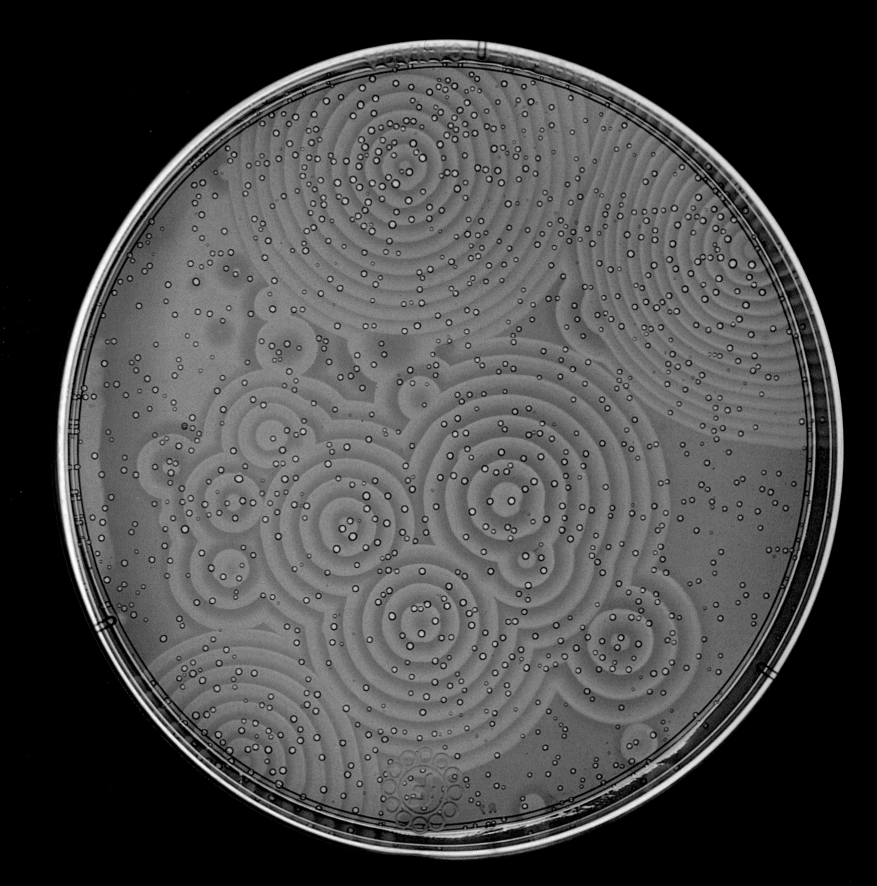

FELICE FRANKEL AND GEORGE M. WHITESIDES

On the
Surface
of Things

IMAGES OF THE EXTRAORDINARY IN SCIENCE

CHRONICLE BOOKS

SAN FRANCISCO

Image facing title page: *Patterns from an Oscillating Chemical Reaction*

Image at right: *Fragments of a Thin, Broken Film*

Image facing introduction: *Features Etched into Silicon with Light*

Printed in Singapore

Book and cover design: Stuart McKee

Library of Congress Cataloging-in-Publication Data:

Frankel, Felice.

On the surface of things: images of the extraordinary in science

/ Felice Frankel and George M. Whitesides

 p. cm.

Includes bibliographical references and index.

ISBN 0-8118-1371-1 (hc)—ISBN 0-8118-1394-0 (pb)

1. Surfaces (Physics) 2. Optical Images. 3. Surfaces
(Physics)—Pictorial works. I. Whitesides, G. M. II. Title

QC173.4.S94F73 1997

530.4' 17—dc21 97–852

 CIP

Distributed in Canada by

Raincoast Books

8680 Cambie Street

Vancouver, B.C. V6P 6M9

10 9 8 7 6 5 4 3 2 1

Chronicle Books

85 Second Street

San Francisco, CA 94105

Web Site: www.chronbooks.com

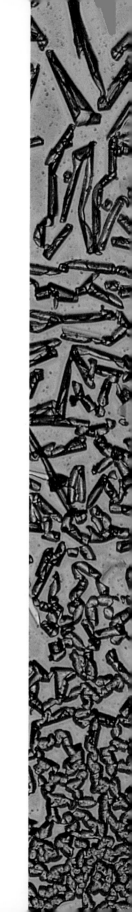

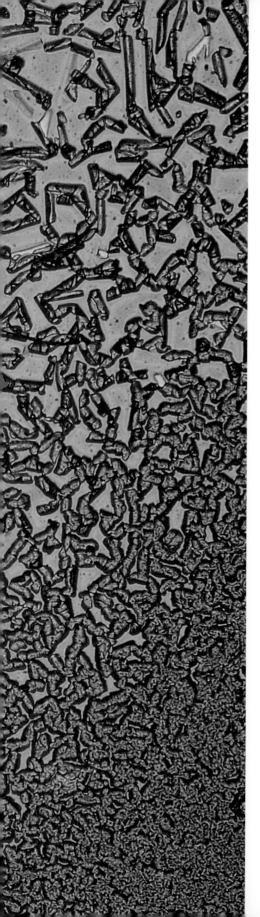

contents

introduction

Surfaces define the shapes of our world; light allows us
to see them. This book is about surfaces, and light, and how
they interact.

Understanding nature and natural phenomena—science—can
be a joyful activity. Deciphering the rules that regulate the
physical world provides puzzles for a lifetime; these rules also
spawn the technologies that so enrich and vex us. Nature has
the capability to beguile endlessly, and in describing nature,
science shares that capability. But science is also like a
rose bush: the flowers are ravishing, but they are protected by
spines—by technical, analytical, and mathematical details—
that are most uncomfortable to embrace. In this book, we try
to display some of the flowers and avoid the thorns.

The book originated in an improbable coincidence of
interests in science and images. One of us, Felice Frankel, is
a photographer who has worked with the interaction of
nature and humanity on a grand scale—in landscapes. She
became enthralled by science, by the possibilities of powerful
imaging in science, and by the general ineptitude of scientists
in exploiting those possibilities. The other, George
Whitesides, is a chemist who works at the other end of the

scale of sizes, making molecules and microstructures.
In his years of teaching university students he learned, among
other lessons, that equations and scientific graphics rivet no
one's attention. We agreed that arresting images were uniquely
effective in describing nature. A single image organizes a
deluge of information in a form that is easy to understand.
An image that is rich in composition and color always catches
the eye. And what catches the eye, catches the mind.

The photographer's optimistic view was that it is possible to
make any subject visually arresting; the scientist's opinion
was that it might be harder than it seemed. We agreed to try
the experiment, and this book is the result. We chose the
subject—surfaces, and the light that illuminates our view of
them—because surfaces are what we see of objects, and
because they are important in the two great technological
invasions, universal connectivity and engineered life, that are
now overrunning and remaking the world.

Universal connectivity promises that computers will let
us find whatever we want: information, one another, wealth,
opportunity, equality. Engineered life views us, and all
living things, as wondrously complicated machines: collections

of devices patched together by evolution, with myriads of molecular parts, and with thick instruction books—the genomes—open to view. As a society, we are of mixed mind about both invasions. Access is what we gain from them—to one another, to knowledge, to opportunity, to dominion. Privacy is what we lose—the separateness of self and the mysteries of the body. Our familiar concept of a person, as an individual distinct from other individuals, erodes in a storm of bits. We might try to close the door against the gale, but the bits would still swirl into every corner. We have no way to go back; we can only appreciate, understand, and ride the wind forward.

Both computers and living organisms are built of small things, and surfaces are especially important for them. A transistor—the building block of computers—is a tissue of invisible surfaces spun into silicon. A living cell—the universal unit of life—is a collection of molecules that interact through the touch of their surfaces. Surfaces are also, in some sense, a separate state of matter, distinct from solids, liquids, and gases: the properties of matter change most rapidly at surfaces. And as for light: We are a species that specializes in seeing. Sight is our clearest window on the world and also our delight:

we would not forego seeing the faces of our children, or dawn, or the leaves spinning in the wind in autumn.

Images are a language all can understand. Most of the images we have chosen for this book share four characteristics. First, their color, form, and composition catch the eye independently of their subjects. Second, they are nonrepresentational. Third, they are unfamiliar: either they are images of objects that few people have seen, or, if of familiar objects, they show unfamiliar views. Fourth, each illustrates subjects of current scientific research, and presents information of the sort (if not of the form) that underpins science and technology.

Beautiful images connect humanists and scientists. Both need a clearer understanding of the forces that shape our world, and scientists need better languages with which to share their enthusiasm for natural phenomena. We offer these images and descriptions to the reader who wishes to know more about nature, science, and technology. Technical and photographic notes and literature references end the book.

We invite you, the reader, to share our love of science, and images, and words.

the sizes of things

Without a sense of size, images are ambiguous. A mammalian cell up close and a cluster of stars far away are both too small to see; magnified, but with no further indication of size, they may be difficult to tell apart. Our emotional response to a polar bear and to a shrew — both ferocious predators — is based on knowing our size relative to theirs.

The images in this book are difficult to interpret without knowing their sizes. We use the metric system to describe them for two reasons. First, the metric scale is universally used in science and technology. Second, it has the convenient feature that all lengths are given as fractions or multiples of 10 and are based on a single unit of length — the meter.

Most of the images in this book are of objects smaller than a meter. A meter is approximately a yard — about three feet. A centimeter is one hundredth of a meter, or approximately one-half inch. A millimeter is one thousandth of a meter — the size of a pinhead. A micrometer (often called a micron) is one millionth of a meter, or one thousandth of a millimeter. A one-micrometer object is too small to see without magnification: the period at the end of a sentence is approximately 500 micrometers in diameter; a fine hair is approximately

100 micrometers in diameter; a red blood cell, which is invisible to unaided sight, is 10 micrometers in diameter; visible light has wavelengths of about one-half of a micrometer. The smallest measure we use is a nanometer — one billionth of a meter. An atom is two-tenths of a nanometer in diameter.

The smallest features in the images in this book are about a nanometer in size; the largest are approximately 10 meters. Most of the objects are between 1 micrometer and 10 centimeters in size — a factor of 100,000. To avoid the mental arithmetic of estimating sizes for each object from words, we have supplied a familiar shape — the head of a pin — to use as a reference. (A pinhead is a circle one to two millimeters in diameter.) For images of large things, the relative size of the pinhead disappears to a dot; for images of very small things, the relative size of the pinhead may be much larger than the page, and we show only a section of its circumference. A quick comparison of the size of the object to the size of the pinhead should help readers imagine the proper scale for each image. Further details about some of the sizes are included in the technical descriptions in the "Notes and Readings" section at the back of the book.

DIAMETER OF A PINHEAD AT ACTUAL SIZE

for images of large things, the relative size
of the pinhead disappears to a point

DIAMETER OF A PINHEAD MAGNIFIED 10 TIMES

DIAMETER OF A PINHEAD MAGNIFIED 50 TIMES

11

DIAMETER OF A PINHEAD MAGNIFIED 125 TIMES

DIAMETER OF A PINHEAD MAGNIFIED 1000 TIMES

for images of very small things, the relative size
of the pinhead may be much larger than the page,
and we show only a section of its circumference

light

light

is the insubstantial

foundation of our world.

Light is the chirps made by electrons as they change: from one position to a more stable one, from one speed to another. These chirps are brief, shrill warbles of electromagnetic radiation. The chirping of electrons is profoundly different from the chirping of birds—quantum phenomena influence the interactions of light with matter in ways that have no perfect analogy in everyday experience. And yet they are also similar in that both involve waves—for light, waves of electromagnetic radiation; for sound, waves of pressure in air.

The terrain through which light travels is space and matter. To light, matter is pools of electrons collected around atomic nuclei. Where the pools are deep, light travels slowly; where the pools are shallow, it moves rapidly. Most phenomena involving light—bending, reflection, absorption—result from encounters of waves of light with the pools of electrons in matter. Light interacts strongly only with electrically charged particles, and especially with electrons: we perceive this interaction primarily as the absorption and emission of light in the colors of the visible spectrum and as heat.

Light is the insubstantial foundation of our world. The energy from the sun that fuels life arrives as light, both the colors we see and the forms of electromagnetic radiation that we usually do not think of as "light"—radio waves, heat, ultraviolet light, and X rays. We see with light: it is the air perception breathes. We communicate and measure with light. We use light to talk, write, and move objects, and to machine and weld matter.

A car drips dirty oil; a drop falls onto water in the mud. There it spreads and forms a rainbow skin as beautiful as that of any salamander. The drop is pulled nearly flat by the water. The molecules of water exposed at its surface with air are uncomfortable. Molecules are most stable when in contact with other similar molecules on all sides. Water molecules exposed to air are partially "bare," and thus higher in energy and less stable than those in the interior of the puddle. These surface molecules are more comfortable when covered with a skin of oil. Detergents added to the oil to help it cover surfaces in the engine of the car also help it to cover the surface of water. With enough time, the oil will be pulled to a thickness of only a few hundred molecules. A small quantity of oil will cover an amazingly large area: a tablespoon full, as a single molecular layer, would cover a surface the size of several football fields.

○ o i l s l i c k

The film of oil creates two imperfect mirrors—surfaces that are flat, approximately parallel, but only partly reflecting. A light wave first encounters the surface between the air and the oil; some of it reflects, some continues on into the oil and encounters the surface between the water and the oil. Here again, some reflects and some continues. When we look at the oil slick, we see the combination of the reflected light waves. Because the two mirrors are close—the distance between them is similar to the wavelength of light— light reflecting from them interferes with itself: that is, waves of light reflecting from one mirror augment or annihilate waves reflecting from the second.

The colors measure the thickness of the oil, with only one color reflecting for a particular thickness. Each passage from red to blue corresponds to the addition of approximately 200 molecules of oil to the thickness of the film. Amazingly, simple observation can infer the structure of nature at the molecular scale: by looking at the colors, one can estimate changes in the thickness of an oil film from place to place to within perhaps 50 molecules, which is five hundred-thousandths of a millimeter (or two millionths of an inch).

Thin oily films are ubiquitous. These films contain molecules—hydrocarbons—that are chains of carbon atoms combined with hydrogen atoms. Such compounds are the basis of gasoline, lubricants, and soaps; they also occur naturally in the decay of plant matter in the absence of oxygen. Because they tend to form colorful films when they float on the surface of water, they are highly visible evidence of environmental contamination.

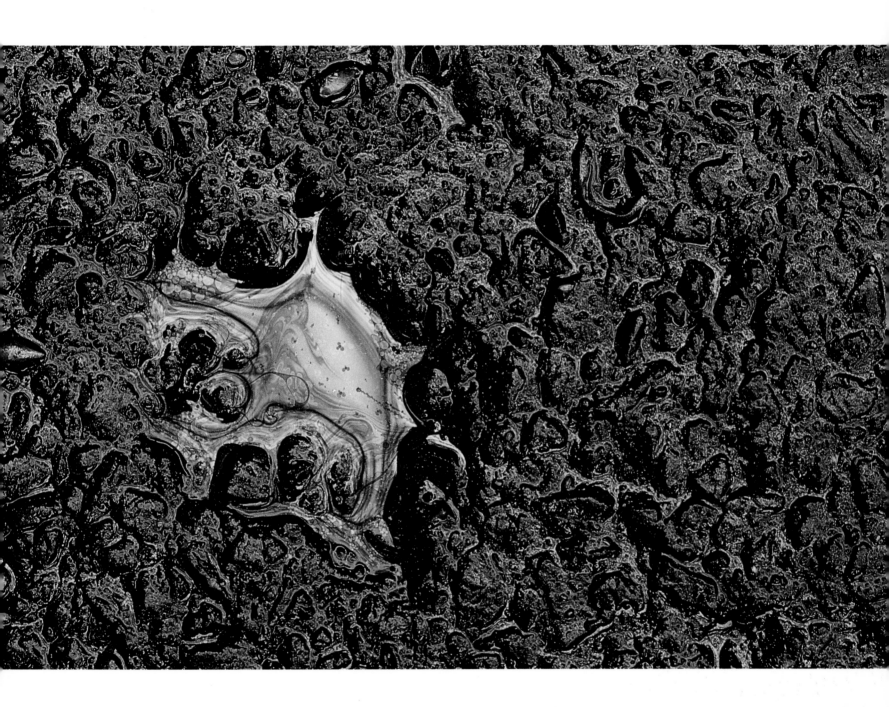

Light is hard to steer: it has no handles we can grasp—no mass, no charge. Electrons are more docile. They can be guided with electrical charge, toward positive charge and away from negative. A computer screen is a billboard on which we paint patterns of light using electrons as the brush. We guide the electrons, which we cannot see, to form the light, which we cannot guide.

Most computers and television sets use cathode ray tubes as their display screens. These are large vacuum tubes that generate a stream of electrons and spray it onto the light-generating surface. The stream is pumped from a wire into the vacuum and passes between charged metal plates. Moving the electrical charge between the plates steers the electrons. When the

electrons careen into the screen, they strike light-generating atoms (phosphors). After impact, the electrons in the phosphors ring like the bells of a carillon: each kind vibrates in a characteristic color. Only a few different phosphors are needed; their combination provides the full visible spectrum. Each glowing spot is the ghost of dying electrons, the transmogrification of kinetic energy into light.

Understanding the processes that cause the phosphors in the displays of computers and television sets to lose their colors, and the electron beam its accuracy, aids the design of brighter and longer-lived displays.

computer monitor screen

A pebble dropped in a still pond spreads circles of ripples. Matter is pools of electrons held in place by atomic nuclei. Electrons carry a negative electrical charge, and negative charges repel one another. When one electron moves, other electrons feel that movement. Light is the ripples when these pools of electrons are disturbed.

If you could glue an electron to a spring on the surface of the sun and set it to vibrating rapidly — 500,000 times per second — electrons at the surface of the earth would feel that vibration eight minutes later. What we call light is the influence of one vibrating electron on others. Here, it is light that vibrates too slowly for our eyes to recognize — we would call it radio waves — but it is light, nonetheless.

For a single vibrating electron, this light would be far, far too weak to be detected by any means. If it were made much stronger, by large numbers of electrons or ions (atoms missing electrons or attached to extra electrons) oscillating together, a radio could detect it. Only if the vibration were a billion times faster — 5×10^{14} or 500 million million times per second — would we perceive it as visible light.

The intricate interaction we call seeing is electrons vibrating in response to other electrons. When we see, electrons in our eyes — in molecules in the retina — vibrate in response to movements of electrons in the scene on which we gaze; this vibration is translated into messages to the brain. When we see the sun, we are sensing the violent motions of electrons and ions on its surface. When we see the reflection of the sun on water, we are seeing the movements of electrons in the water, responding to movements of electrons in the sun.

The surface of the sun is not, of course, smoothly vibrating electrons and ions: it is cacophony, a superheated stew of electrons and atomic nuclei at full boil, spewing light of all colors — radio waves, microwaves, heat, the visible colors, ultraviolet light, X and gamma rays — in all directions. At our safe distance, beneath the protective sea of our atmosphere, with our very limited eyesight, we see only the distant light that we mistake to be a pure color, "white."

18

reflections of
sunlight on water

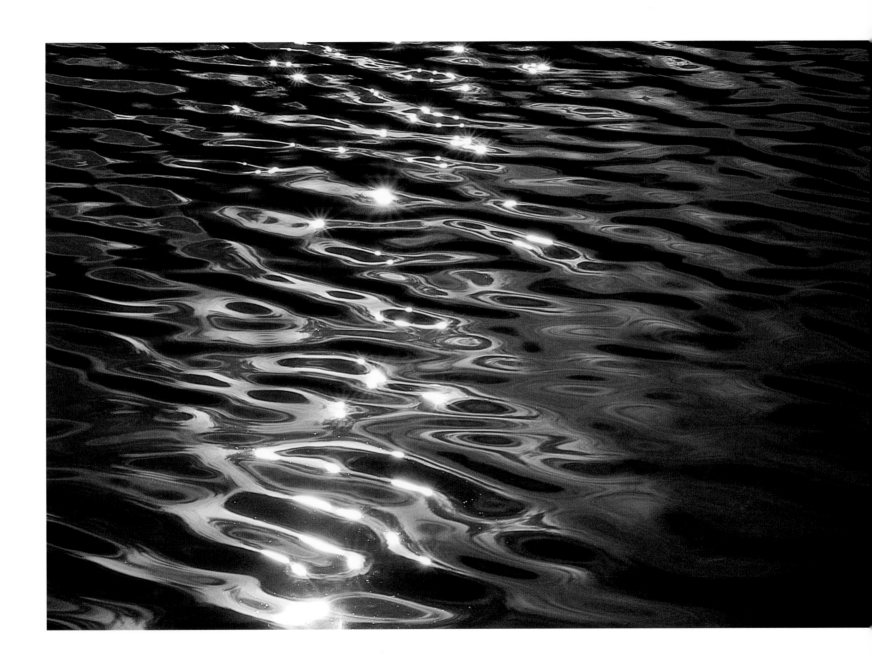

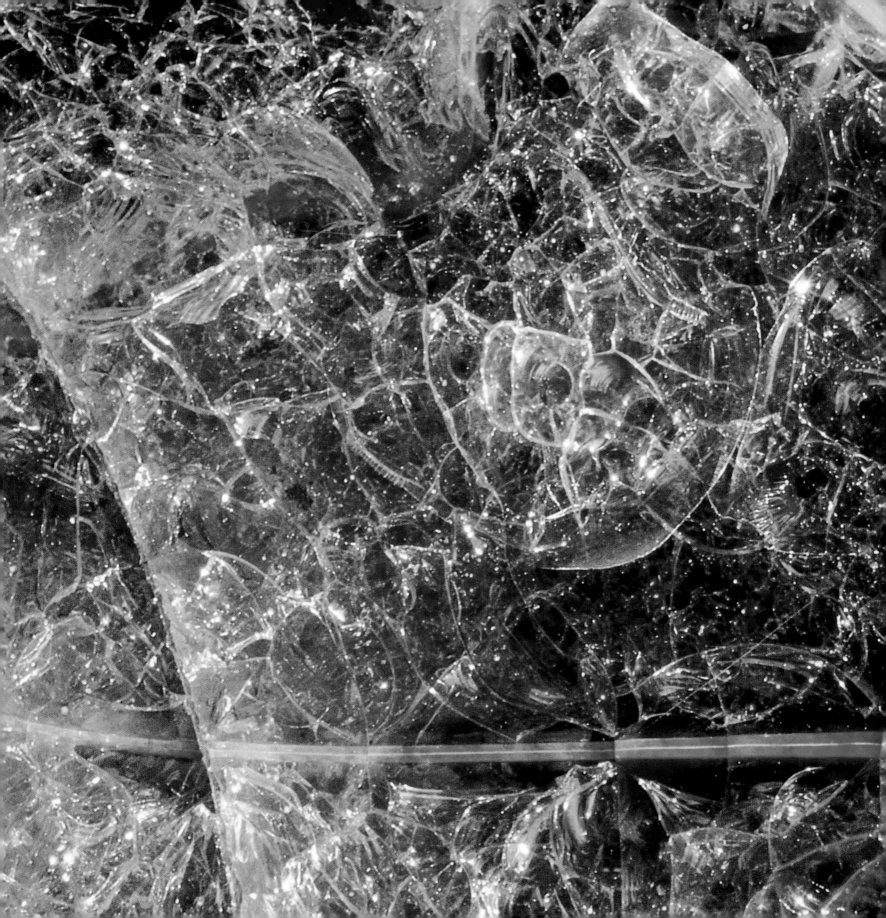

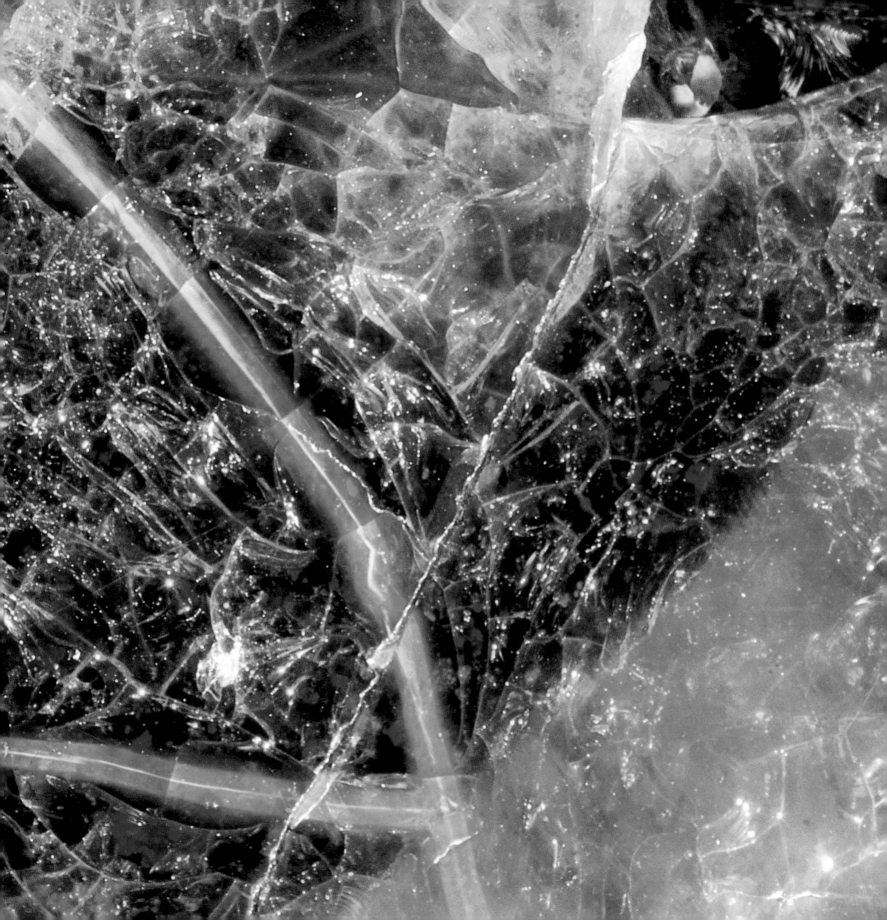

veins of opal

PREVIOUS PAGES

Opal is a complete surprise. It would be no less surprising to find necklaces of perfect pearls forming spontaneously in a drainage ditch. Opal is formed by simple heating and cooling of water in an underground crack, in a process that generates arrays of spheres that separate white light into pure colors—diffraction gratings. From dilute mineral broth to rainbows frozen in rock: spontaneous generation of order from disorder.

Over time, cracks in rocks filled with hot water that slowly became saturated with silica extracted from the rock. Very, very slowly the water cooled. As it did, the silica precipitated as tiny, uniform, transparent spheres floating in the hot fluid like fish eggs. These spheres settled and arrayed themselves in beautifully ordered sheets spaced apart by a few hundred nanometers— that is, by 200 billionths of a meter, or one ten-thousandth of an inch— coincidentally, the size of waves of visible light. The spaces between

the spheres filled with silica with slightly different properties, and this new material glued the arrays in place. To light, these sheets of spheres are semitransparent mirrors, and light reflects from them in a way that allows only single colors to escape. The origin of the colors of opal, an oil slick, and the wings of the morpho butterfly is the same: diffraction, waves of light reflecting from arrays of parallel planes and augmenting or destroying one another.

Opal demonstrates that three-dimensional, ordered arrays of small particles with remarkable optical properties can form spontaneously and without our participation. This type of process is called self-assembly. *We* are not involved—the process proceeds and generates a complex structure by itself. Designing self-assembling processes to make complex, functional materials according to our specifications is an important new strategy now being explored in electronics and optics in the hope that it will simplify the manufacturing of these materials.

The pitch of organ pipes is determined by the length of the resonant tubes. The longer the pipe, the deeper the note. The color of the light given off by electrons in solid particles is also determined by the size of their box, the particle in which they vibrate. The larger the box, the lower the "pitch" and the slower the vibration. Ultraviolet light from electrons in a small box is too shrill—too fast—for our eyes to see. The vibrations slow through the colors blue, green, yellow, red, and finally basso purple, before the pitch falls into the infrared, invisible to the eye but perceptible to the skin as heat.

These vials contain suspensions of particles of cadmium selenide with diameters between 2 and 8 nanometers; the particles are "quantum dots" shaped to be carefully pitched organ pipes for electrons. The quantum dots are boxes just small enough to give electrons claustrophobia, each sized to give off a different color when ultraviolet light causes its electrons to vibrate. Ultraviolet light is energetic and causes the particles to give off bright visible light—fluorescence. With visible light, which is less energetic, the suspensions absorb rather than emit light, and they appear as pale, transparent pastels.

These colors may someday be used in computer display screens. The colors in current displays rely on the range of different phosphors in the screen. Generating a complete range of colors out of particles with different sizes of a single material may simplify the design and manufacture of these ubiquitous screens.

suspensions of small,
fluorescent particles

A madrigal is a rich polyphony. Silence all the parts but one and what remains is simple melody. "Color" is "white light" with most of the parts gone: the blessing of color comes by subtraction. A red rose is a sponge that sucks the blue and yellow from white light; this red plate and red paper trap all colors other than red. White light offers a palate of all colors to objects; they remove some, and their "color" is the light they reflect.

Seeing color has features in common with the sympathetic vibration of tuning forks. A tuning fork tuned to A (440 cycles per second) will ring sympathetically only to that tone, regardless of other sounds and other frequencies in the music. An electron in a molecule is similar: it can vibrate only at certain frequencies. Electrons in one molecule can respond to vibrations from a second by ringing in sympathy or by resting in indifference. The electrons in the molecules of a colored object respond to light of the same color by vibrating at the same frequency and emitting clearly the "tonal" wavelength that set them going. The electrons damp other colors—other frequencies—in the light; these colors are subtracted from the light emitted.

When we see a surface that has been illuminated with white light as red, the electronic tuning forks that oscillate at the frequency of red in the object are ringing clearly (albeit at 5×10^{14} ripples in the electromagnetic pool each second); the frequencies corresponding to yellow and blue are damped and their characteristic colors are sucked from the reflected light.

25

the color red

tubular gels

Slap the face of a guitar sharply with your hand, and the strings will vibrate gently. The electrons in a molecule react the same way: slap them with ultraviolet light and they may answer with a gentler vibration—of visible light. Our eye cannot see the ultraviolet slap; we can only see the more slowly oscillating visible response.

These "tubes" are molded gels—gossamer, transparent networks of long, interconnected organic molecules swollen with water: a three-dimensional "fishing net" with strands a few tenths of a nanometer across. Molecules of fluorescent dyes are attached to these strands like fish caught in a net. In visible light, the networks of tubes are transparent, invisible to the human eye. Irradiating the dyes with ultraviolet light renders the translucent gels visible.

The gels are potentially useful to us because they can swell or shrink enormously—by as much as 1000 times their original volume. Small changes in the acidity of the solution permeating the gels bring about the great change in volume, and they can also change volume if salts—including table salt—are added to the water. The gels may be developed for trapping and releasing drugs, for soaking up water, or for serving as a kind of artificial "muscle" to move small objects in water.

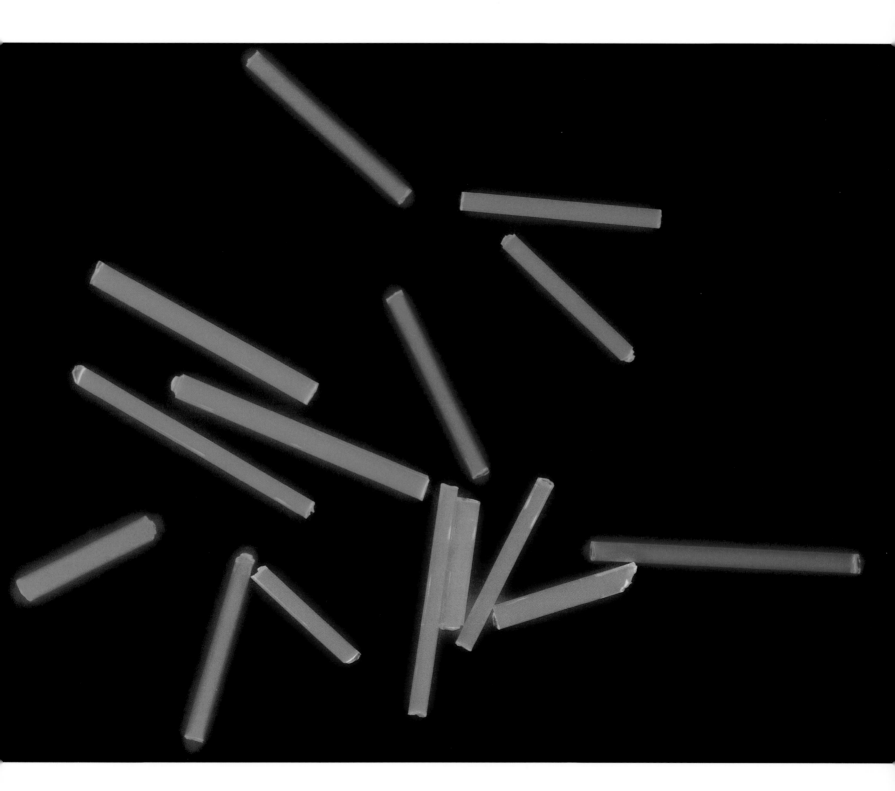

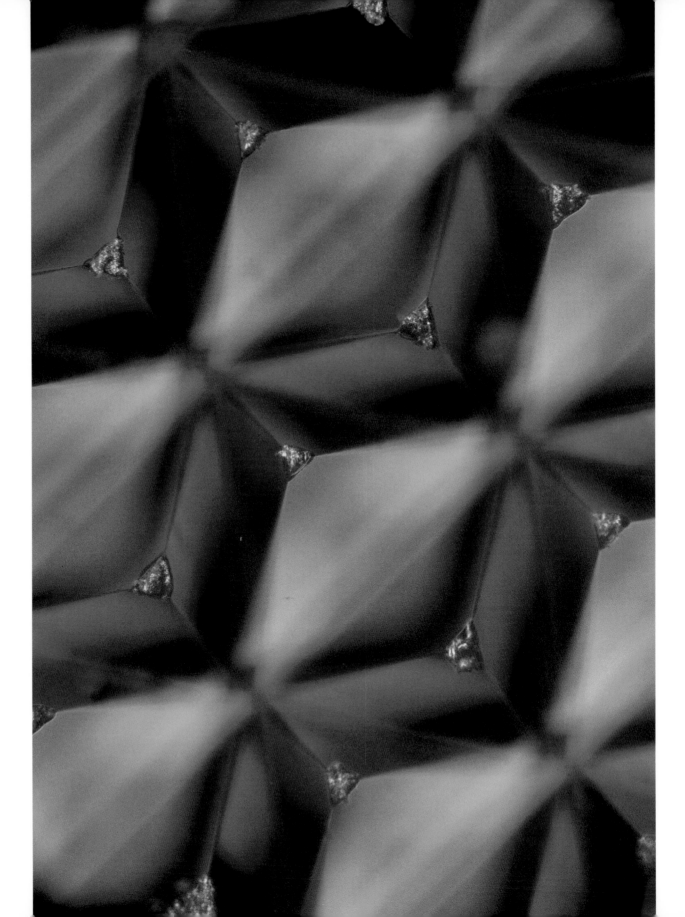

three perpendicular reflective walls. When light falls into one of these pyramidal structures from a broad range of angles, it reflects from the three faces and is thrown back to its origin.

So long as the orientation of the reflecting planes is precisely controlled, the accuracy of the direction of reflection is surprising. A corner cube on the moon can be observed by a radar transmitter on earth; the radar signal the cube reflects is directed toward the transmitter that sent it.

The same phenomenon, with different details, is involved in the reflection of headlights from the eyes of animals at night, and in those flash pictures of families in which all eyes seem to glow the pink of an internally illumi-nated albino rabbit. In these structures light enters the eye and is reflected from the inside surface. Retroreflective elements are used for street signs, reflective pavement markers, and protective reflective strips for bicyclists: all reflect light back to the driver of the car whose headlight is the source of illumination. In the past, street signs and reflective markers have been made of reflective beads that operate as "cats' eyes." The more sophisticated corner cube structures are now taking their place, as micromanufacturing and optics are being applied to consumer products.

In pinball, there are bumpers that reflect the ball back in the direction from which it came: two rubber bands at right angles, anchored at the ends. The ball enters, bounces off one band and then the other, and rebounds toward its origin in a retroreflective flight. When light encounters a simple mirror at an angle, it ricochets from the surface at that same angle but in the opposite direction—away from its source. Retroreflecting ("reflecting back") structures reflect light *back* toward its source.

These retroreflecting structures are an array of corner cubes molded into the back side of a sheet of plastic. A "corner cube" is half of a cube—

retroreflectors

optical waveguides

PREVIOUS PAGES

Connections are as important as origins and destinations. Heart and lungs get the attention, but veins carry the blood. Transistors without connecting wires are just microscopic runes carved in silicon. Photonic devices— devices that manipulate light— need optical waveguides—pipes for light—to move the light from place to place.

The electron is an elementary unit of electricity, and "information" in microelectronic devices is groups of electrons. Electrons can be pumped and stored in metals and semiconductors. The photon is the elementary unit of light, a chimerical creature that can behave like a wave or a particle, depend- ing on what it is doing. "Information" in a photonic system is groups of photons—brief bursts of light—mov- ing through optical fibers.

Optical fibers are thin rods of unimag- inably transparent solid glass—1000 miles long, yet clear from end to end. These rods are made of two kinds of glass with slightly different properties: a thin core of one kind, and a thicker wrapping (a "cladding") of the second. The difference in properties traps the light in the core. The fiber guides its photons delicately: light travels slightly slower in its center than at its periphery, so if the light strays from its path at the center, the subtle changes in speed steer it back again. A photon travels along the core of the fiber like a ground squirrel scuttling through its tunnel.

Glass fibers are miraculously transpar- ent, but they are also expensive and, like all glass, brittle. In applications that pump light over short distances, wave- guides are sometimes plastic. Although their performance is poorer than that of glass, they are cheaper and easier to make and use. The individual members of this array of several thou- sand plastic waveguides are too small to be seen without magnification; the array itself acts as a diffraction grating— a structure that disperses light into its individual colors.

These bands and spirals are wires on the outside of glass fibers. They could be the final technical accomplishment of a jeweler obsessed with miniatures: exquisite craft too small to see. The spirals are the wires for small electromagnets; the bands are stencils for building mirrors. The fibers on which they are wound are approximately the diameter of a fine human hair; some are solid, some hollow. The wires patterning their surfaces are copper, silver, and gold. Both bands and spirals are made by printing a protective paint a single molecule thick on a continuous metal film covering the outside of the fiber, and removing the unprotected parts of the metal by etching.

The telephone system in New York talks to that in Chicago through optical fibers. The light must be directed correctly from its source to its destination, and mirrors provide one tool for directing light. Mirrors — really thousands of mirrors, each only slightly reflective — are constructed in the center of the fiber. The strategy used to construct such a stack of mirrors and refine it to allow only some wavelengths to pass or some to reflect is to make the core look like a thousand-layer cake,

with the layers thin slabs of glass with slightly different properties, and with thicknesses approximately the length of a wave of light. One way to form this stack is to stencil a raccoon's tail of copper bands on the outside of the fiber and to shine light through it. The pattern of light in the center of the fiber is that of light shining through Venetian blinds, but in bands 10,000 times narrower and much brighter. If the light is intense enough, it burns a pattern into the core — an ultraviolet sunburn in the glass. The remarkable result is a multi-tiered stack of transparent mirrors along the core of the fiber.

Optical fibers are the smoothest highway for shipping information over long distances: telephone messages, internet traffic, commercial transactions — all can move as pulses of light over glass or plastic fibers. As the use of fibers increases, there is more need for methods of picking particular streams of information off the fiber. These mirror-gratings provide the capability of manipulating the light in the core of the fiber without electronic equipment. They are very attractive components for optical communications, since they have no parts to wear out and require no power.

33

metal patterns
on glass threads

silicon, etched
by light

We know light best in its diluted form: a gentle rain of photons falling from the sun that illuminates and warms. More concentrated, light is a furnace and a terror.

The surface here is silicon, the element that forms the basis for the microprocessors used in computers. It is very hard, very strong, and very brittle. Machining silicon—carving it into pieces—and seasoning the pieces by adding traces of boron, phosphorus, and arsenic to change its electronic properties is the art of microelectronics fabrication. Without this art, making transistors would be impossible.

Many tools are used to shape and transform silicon. A new one, made possible by the development of lasers, is light. When the focused spot of

intense light from a laser traversed the surface of this flat piece of silicon, lanes of parallel, closely spaced lines—like those left by combines moving through wheat—were burned into the surface.

Silicon melts only at a very high temperature and boils at an even higher one. It is also unreactive. Here, the stream of photons was intense, and each photon that was absorbed deposited its energy as heat. The hot silicon combined with a reactive gas, chlorine, present in the atmosphere over its surface. The product of this reaction, silicon tetrachloride, boiled away, leaving the grooved lines in its place. The numbers are reference marks left in the untouched part of the surface.

Microelectronic devices built from silicon are everywhere and invisible: in computers, electronic ignitions of cars, television sets, telephone systems, and elevator controls.

form

We are drawn to surfaces
for their reality. Surfaces define f o r m;
form reflects utility
and history.

Pick up a baby, an apple, a knife; their surfaces tell you their shape, and their shape tells you what you have.

We are drawn to surfaces for their reality. Surfaces define form; form reflects utility and history. Surfaces are especially important for the forms of fluids and small things. Atoms exposed at the surface of any material are less stable — less comfortable — than those buried in the interior: liquids and solids try to reshape themselves to minimize their exposed surfaces. More of a small object than a large one is surface, and the desires of the surface atoms to escape exposure influence the form and performance of small things. It is easy for a liquid to contract its surface, and minimization of liquid surfaces shapes drops and films. Solids cannot change shape, and must use other strategies to cover their exposed surfaces.

A gear, with teeth transmitting force; a transistor, with hidden channels metering electrons; a knife, with its cutting edge — for each, function follows form. Snowflake and raindrop are water shaped by natural processes: their forms are their faces, and tell their stories. Form emerges from design, fabrication, and manufacture. Form also grows from natural forces, without our intervention.

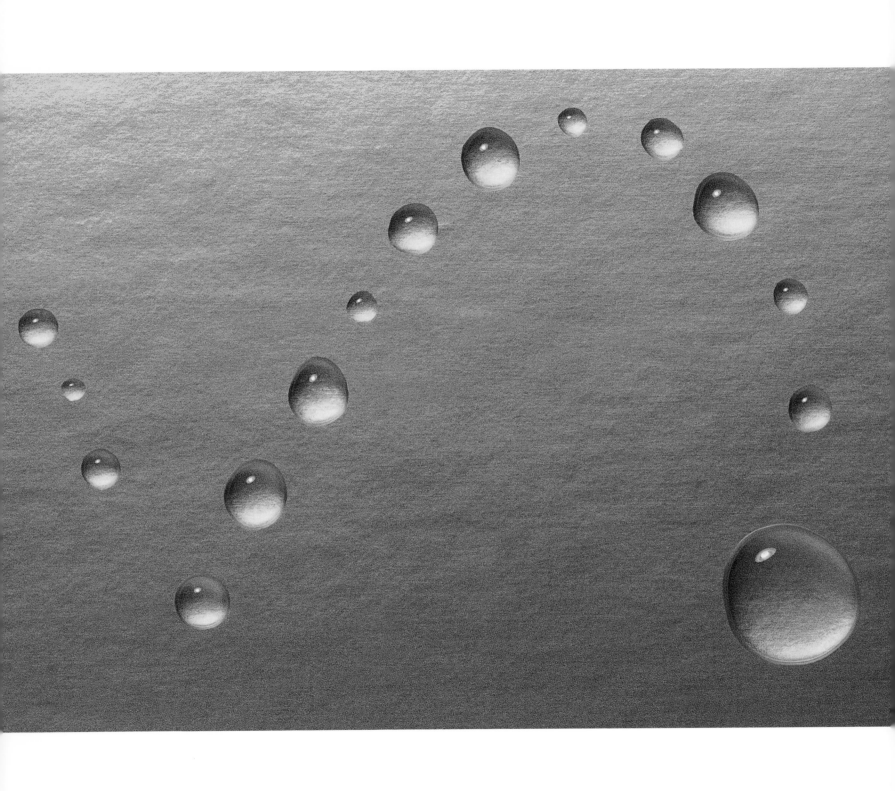

drops of water

Starlings scatter to feed, and clump to sleep. They are attracted to the fields or to one another.

Water draining from a freshly washed dish sheets or beads: it forms either a thin continuous film, or separated drops. The surface of water exposed to air tries to contract the drop; the surface of the dish tries to expand it. Competition between the single layer of water molecules at the surface of the drop and the single layer of molecules at the surface of the dish determines the shape the water takes. Either the molecules of water are attracted by the surface of the dish more than to one another, or they are attracted to one another more than by the dish. The shape of a drop is established by its outermost single layer of molecules—it is visible to the eye. Remarkable. The shape of a drop is one of the few places in nature where we can see the action of single layers of molecules.

It is straightforward to explain beading of drops: molecules in the surface of the water attract one another more than they are attracted to the surface of the dish. It is more difficult to explain the pattern of separated drops. As the water slides from the dish, it initially forms a continuous sheet many thousands of molecules thick. As this sheet of water becomes thinner, the tendency of its surface to contract becomes greater. Small ripples on the surface of the water, or small spots of different wettability on the dish, cause the sheet to break apart.

Whether a film of liquid remains continuous or breaks into drops determines the efficiency of condensers in power plants, the coverage of surfaces by paint, the condensation of mist on ski goggles, and the comfort of contact lenses. The wetting and spreading of liquids influence performance wherever a liquid contacts a solid surface.

ice crystals

When something interesting happens on the street, a clump of people gathers to watch. The clump itself becomes an attraction, and passers-by attach themselves to its periphery. The crowd first grows irregularly, then it becomes continuous as more people push in. The formation of ice on the bathroom window in winter is similar to the growth of crowds.

When it is cold enough outside, the temperature of the inside surface of the window falls below freezing. Water from the air condenses, and then freezes. The first, tiny crystals of ice form with difficulty: their volume is small relative to their surface, and they are less stable than larger crystals. They require a starting point — a particle of dust or an especially cold spot — around which to organize themselves.

Once the initial crystals — the crystal nuclei — have formed, their growth occurs smoothly. Water molecules arrive from the air and attach to the outside of the expanding crystal. Because the surface of the glass is colder than the surface of the ice, crystal growth follows the surface of the glass. Here, the patterns of the ice, illuminated in the golden light of a setting sun, trace the patterns of growth of the crystals.

The two major stages in the formation of crystals — nucleation and growth — determine their sizes, shapes, and internal structures. These characteristics are widely important. The flow of powdered drugs into capsules, the dusting of sugar on cookies, the growth of concrete, the strength of steel, the performance of silicon-derived transistors — all are influenced by the properties of crystals.

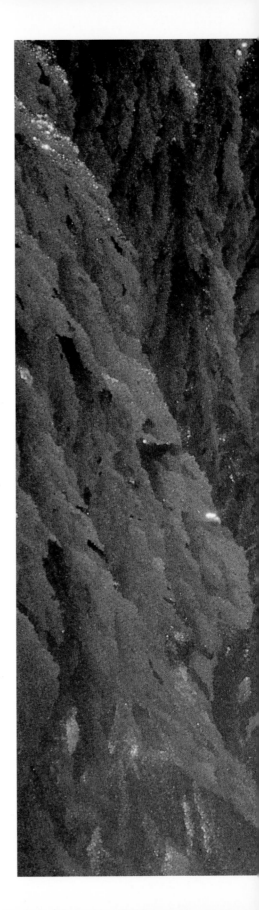

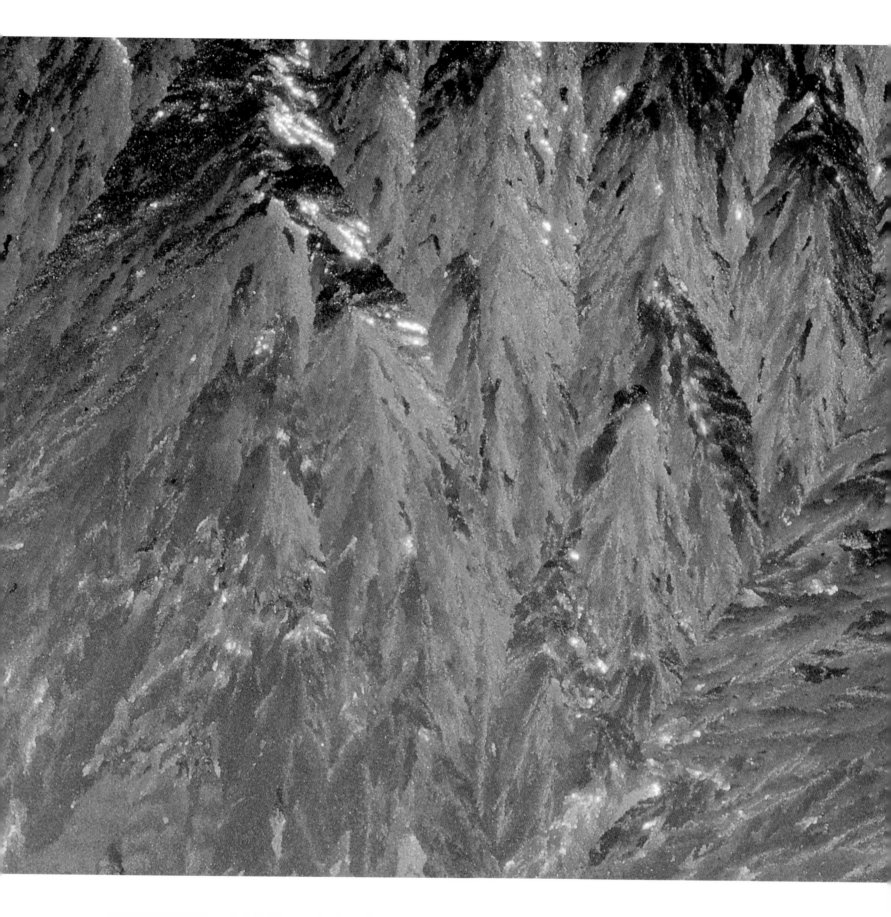

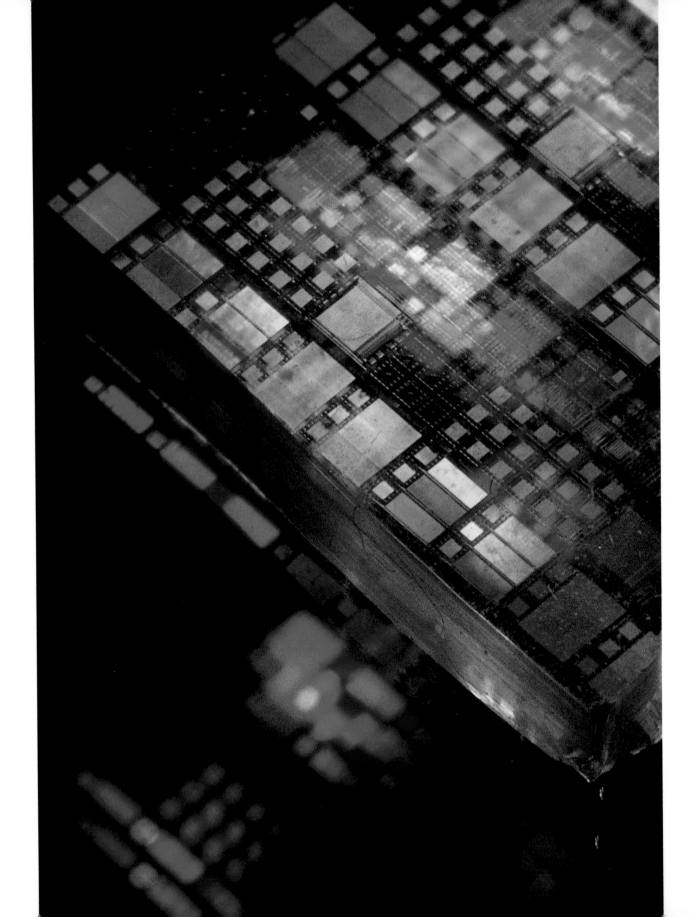

Making things small has become our passion. Medieval popes raised cathedrals toward Heaven that amazed the eye and lifted the soul. We build instead toward invisibility: we cannot even *see* our "cathedrals," our microprocessors and genetically engineered bacteria.

The most elegant of our miniature constructions span a few thousand atoms— a few hundred nanometers, a thousand times smaller than the period at the end of this sentence. They can be carved down from crystals or built up from atoms. Building up from atoms is still difficult; techniques for carving are more developed. Those who sculpt electronic complexities into crystalline silicon first photograph their designs on its surface, and then develop the images into structures the electrons can understand, using disciplined applications of etches, ions, and reactive gasses.

The structures made in the microworld of electronics have shrunk inexorably, and so has the size of the light used to image their designs. Photolithography, the photographic technique used, cannot be used to make much smaller images than it does now. When structures shrink to just half the current smallest sizes, the cameras will fail: no lenses are transparent to the required wavelengths of light—the colors between ultraviolet and X ray. New methods of building microscopic structures may use electrons, ions, or X rays instead of light. A less conventional method is to use a rubber stamp to print patterns.

This stamp is approximately 2 cm across. The depth of the relief of its surface features is approximately 2 microns, and the narrowest of the lines it prints is less than one micron wide. The stamp is transparent to visible light: it looks like a piece of clear glass, although it is rubbery. The "paper" for this stamp is a gold mirror: a gold film 100 atoms thick, supported on flat silicon or glass. The ink is a colorless chemical that adheres strongly to the surface of the gold; the trace it leaves is exactly one molecule thick. The image shows the stamp and its reflection in a mirror. The colors diffracting from the surface of the stamp indicate that the patterns engraved into it are regular and have micron-scale features.

Microprinting is being developed as a tool in microfabrication. Although the patterns formed by these stamps are not visible to the eye, they can direct the attachment of mammalian cells to the surface or control the etching of a gold film. Stamping a film of gold with a pattern, and then etching it, generates small gold wires and mirrors for optical sensors and microanalytical equipment. The gold patterns can themselves be used to direct the etching of silicon.

43

stamp for microprinting

small parallel rods

Sixty years ago, when a child had a cough and could not sleep, a remedy was to allow her to suck on a cube of sugar soaked in whiskey: besotted child slept better than miserable child. The size of the cube of sugar determined the quantity of alcohol administered: a lump of sugar dipped in whiskey was an early technology for drug delivery.

The dry cube of sugar is a tortuous network of capillaries — very small passageways or pores — formed when the particles of sugar are pressed together. When the cube touches the whiskey, the liquid is attracted to the extensive surface of the internal network of pores in the sugar and flows up into the capillaries: the attraction of the solid for the liquid overcomes the attraction of gravity.

The spreading of a drop on a surface and the flow of a liquid into a capillary (capillary wicking) are related phenomena. In both, the solid surface draws the liquid over it. In spreading, the surface of the liquid that is exposed to the air resists expanding even as it stretches. In wicking, since the liquid is moving into a tube,

there is virtually no change in the area of surface exposed to the air, and there is no resistance to the attraction of the solid surface.

This pattern is an array of uniform parallel rods of plastic, each rod much finer than a child's hair. The rods were formed by filling a capillary with a liquid: in this case, a liquid plastic — a slippery spaghetti of long molecules. Placing a rubber stamp with a surface grooved in parallel lines on a glass sheet formed an array of parallel capillaries. A drop of the liquid plastic, when placed at one end of the capillaries, was pulled into them by capillary wetting. The forces that moved the liquid plastic into the capillary were the same as those that pulled the whiskey into the sugar, although the viscous plastic moved more slowly. Ultraviolet light converted the liquid plastic to a solid, and peeling the grooved stamp away exposed the delicate array of rods. The uniformity in their length demonstrates that the capillaries all filled at the same rate; the variations in color suggest subtle differences in their thickness.

Capillary wetting causes ink to blot on paper, diapers to absorb urine, and water to fill the cracks that break granite in winter. It is one of the invisible forces that form the world.

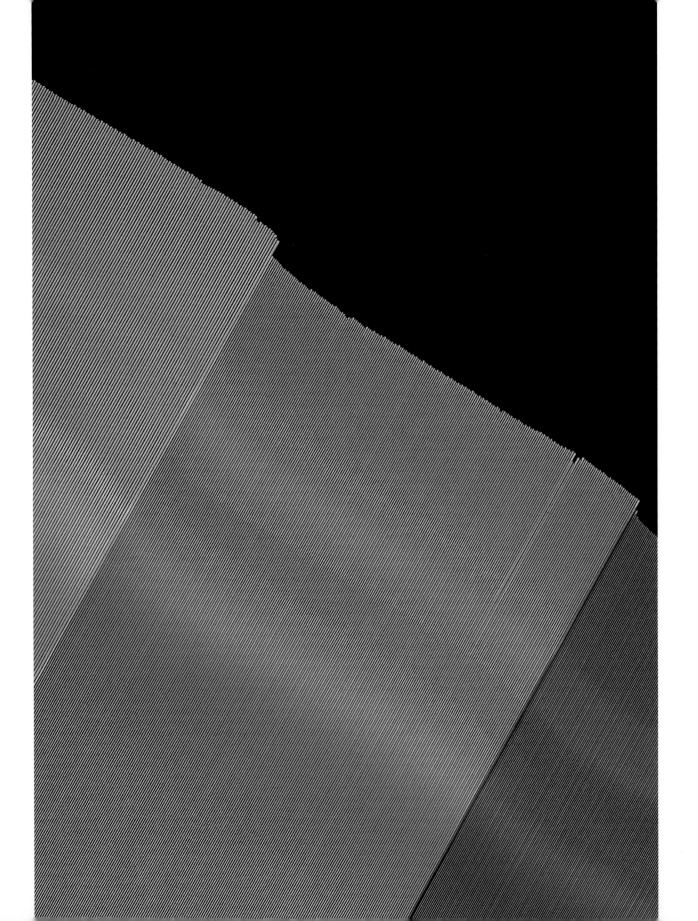

Molecules—like ants, lemmings,
herring, people—are happiest when
surrounded by their own kind.
Molecules exposed at surfaces are always
anxious: on one side they are comfort-
ably surrounded by kith and kin;
on the other is empty space. Molecules
in liquids deal with their agoraphobia
easily: they cluster together and
form compact drops. Molecules in
solids cannot move and cannot cluster.
When a solid finds a liquid, a tug
of war follows: the solid tries to hide
its nakedness by pulling the liquid over
it; the liquid resists, and does its
best to remain a modest, compact drop.

Wine spreading on a linen napkin,
blood staining a cotton bandage, ink
blotting paper—all are contests
the liquid is losing. The same conflict,
played under more complex rules,
describes oil sticking to rock in under-
ground reservoirs, tears wetting contact
lenses, glue sticking to the flap of
an envelope. Matter does not like to
exist bare at surfaces: it will try to cover
itself with anything within reach.

inks bleeding on fabric

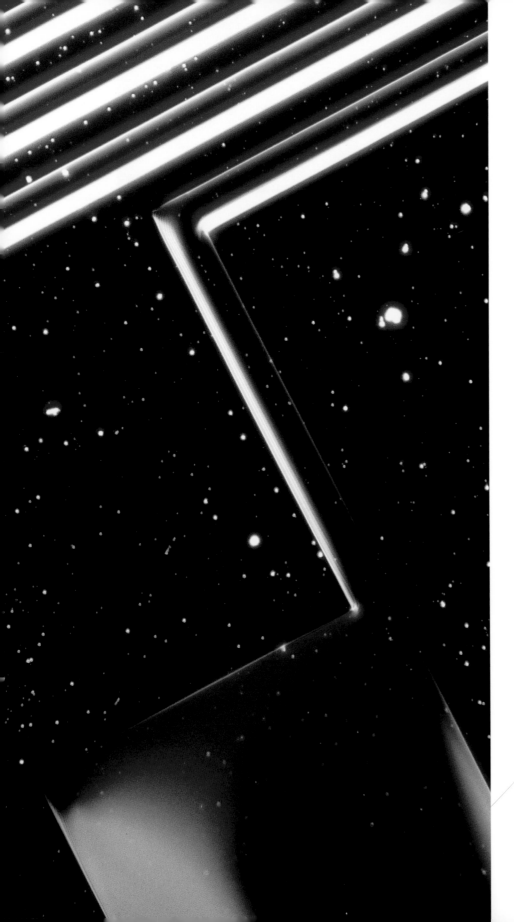

plastic microstructures

These structures are thin beads of transparent plastic supported by glass. A pattern was imprinted on the surface of the glass using an "ink" that formed an image a single molecule thick. When this patterned surface was dipped into a liquid plastic, the plastic wetted only the patterned portions. Withdrawing the sample and curing the plastic yielded these lines.

This process is another example of self-assembly: that is, an important part of the process—the attachment of the plastic to the surface in the desired pattern—took place without human intervention, once the surface had been patterned. Self-assembly—the technique recorded in this image—may be able to replace some older techniques for coating small wires. Self-assembly has the potential to produce highly perfect structures, with less effort and expense than commonly used techniques such as photolithography. It may become significant in manufacturing microelectronic devices, which incorporate enormous lengths of wire in making electrical connections.

47

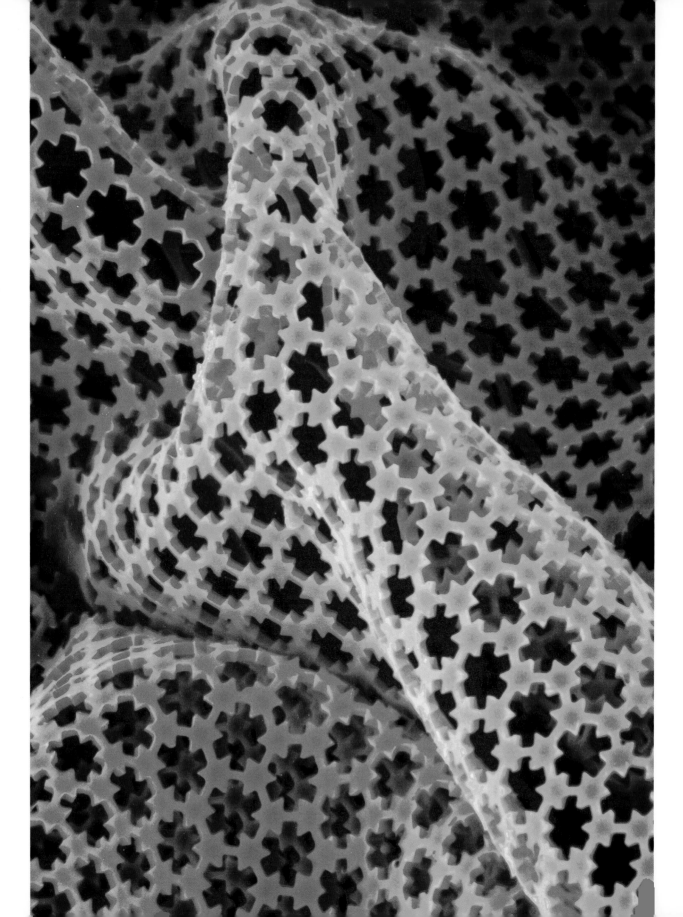

molded plastic microfabric

The spider and the Belgian lacemaker would be envious. Each makes a fabric of admirable regularity and delicacy: the one spins to catch the fly; the other knots to catch the fancy. This lattice-work fabric is more delicate than either; its use may be to catch light.

Its narrowest links are a micron across — one twenty-thousandth of an inch. The finest threads of spider silk are 10 times thicker; the finest lacemaker's thread a ship's hawser by comparison: 100 times larger. To make such delicacy requires a new craft; the older methods do not work. The spider's spinning apparatus is too sophisticated for us to mimic. The spider also works one thread at a time: she cannot spin simultaneously at many points, and her life would be too short to make the enormous number of connections (3 million per square centimeter) in this fabric. As for lace: there are no lacemaker's hooks and needles at this scale, and no human hand will ever be steady enough to do the work.

This fabric is made of molded plastic, not spun or woven: it is like a perforated rubber doormat, reduced in size 10,000 times. The mold was a network of capillaries formed by placing a block of rubber, with a surface textured in the pattern of the fabric, in contact with glass. A liquid precursor of the plastic to be molded, placed at one end of the network, filled it by capillary wetting. The liquid was transformed to solid by shining light on it, and the mold was peeled from the support.

The dimensions of this structure are those of crude microelectronic devices; the finest wires used in high-performance devices are ten times smaller still. One possible use for this type of fabric is as a pattern for photolithography, where it would have the advantage that it could be used once and then thrown away.

self-assembled structure

A biological cell is its own instruction book: it assembles itself. Its complexity comes from the organization of the molecules that make it up. These molecules organize themselves; no force external to the cell plays a role.

The self-assembly of a cell is one of the most marvelous feats in nature. Its molecules sense one another by feel: complementary shapes nuzzle and slide together into pairs, groups, and multitudes. It is a society of molecules—a city-state. It feeds, defends, and repairs itself, and it builds the components that allow it to replicate and form colonies.

By comparison, these cross-shaped pieces are performing a stupid pet trick, like turtles that have been taught to form a figure. They are floating at the surface of a liquid. By design, the liquid wets their bottoms and flat sides. As with soap films and drops of liquid, the surface of the liquid tries to shrink; as it does, the blocks slide together into a regular array. Minimization of the surface area of the liquid pulls the assembly together.

Although these pieces are large enough to be seen unaided, the strategy that caused them to assemble into a regular structure should also work for much smaller units. One future approach to the fabrication of complex structures for information technology—computer memories and microprocessors—might involve making simple components and allowing them to self-assemble into complex constructions. These structures are now manufactured in layers—millions of transistors at a time. The processes used are becoming intractably difficult and expensive, as the computers that use them become unimaginably complex. Any strategy that might provide a simpler alternative is interesting for future computer design. Ideas derived from biology were once believed too unfamiliar and too risky to be considered. Now, there is no choice but to consider the most imaginative strategies.

50

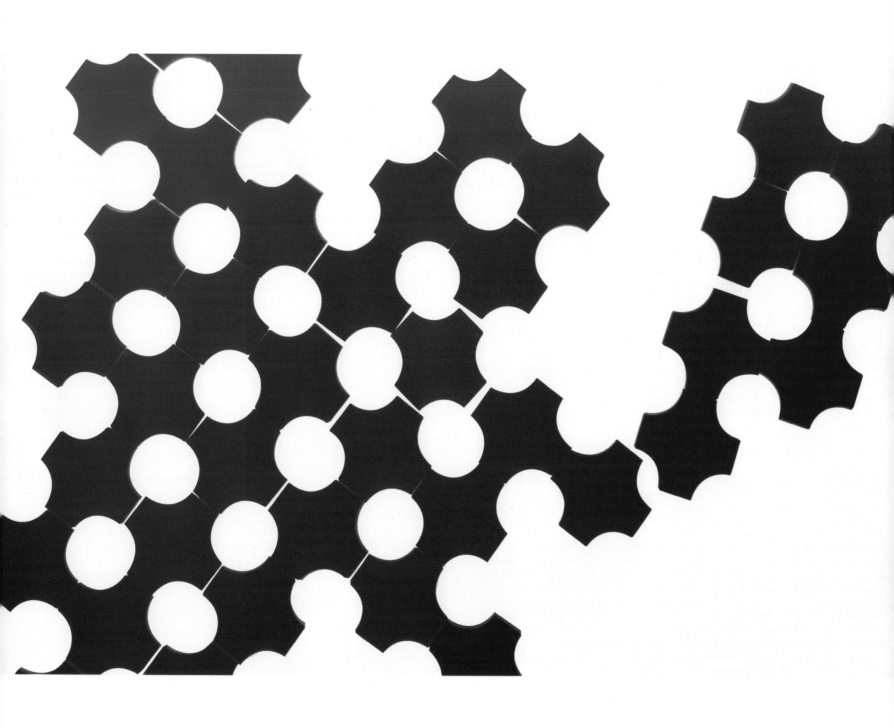

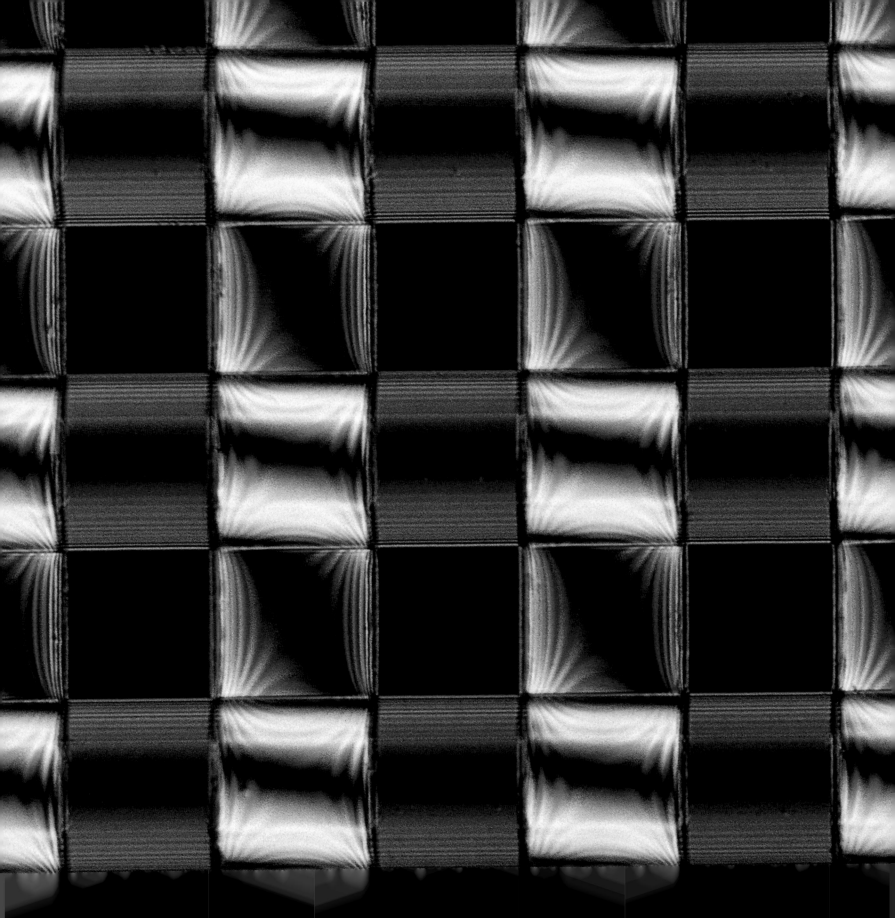

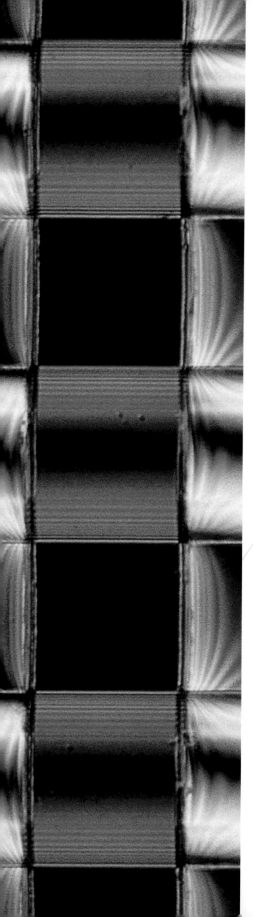

Painting the outside of a house—white on the clapboard walls, blue on the trim—is detail work: slow and expensive. Getting the borders on the trim sharp, and not smearing the new white with blue while edging, is a maddening job. It would be simpler if the paints knew their places: blue *only* on the trim, and white *only* on the clapboard.

This grid is made of silver wires, each covered with a thin transparent film of electrical insulation. The insulation was painted on the wires by a self-assembling process: the paint knew where to go.

Making this structure started with printing a pattern of two different kinds of molecules on the surface of a continuous silver film. The entire

coated silver wires

patterned structure was dipped into the transparent insulating paint, a liquid plastic. The plastic wetted (and stuck to) only the parts of the surface covered by one of the printed patterns; this pattern designated the areas intended to become wires. After the plastic was cured to a solid, the silver surfaces not covered by plastic were removed by etching. Voilà! A set of parallel wires covered with insulation. Repetition of the process with the second pattern perpendicular to the first made the second set of wires.

Self-assembly has the great charm that it works with very small structures. Finding a paintbrush to spread liquid plastic on wires 50 microns wide would not be simple: it is much easier to let the surface and the liquid work it out between themselves.

There is no central planning bureau that oversees evolution. The enormous complexity of even the simplest of living organisms was developed by throwing dice. Biology works by random trials.

It is disconcerting how much more sophisticated the products are from this mindless system than from the research programs that science so thoughtfully plans; it is also remarkable how slowly biology walks the meandering pathway of evolution. We cannot begin to equal the subtlety of a bacterium in our designs; we also cannot try random experiments for a few hundred million years to see if something good comes of them.

multiple experiments

These spots represent a primitive effort to join random and planned experiments. The hope is for a fortunate combination of unanticipated successes from random experimentation, guided by some planning.

A cook tries recipes for cookies a batch at a time, one recipe differing from another by a pinch of this or that, each taking time to mix and bake. Here the "cookies" are very small, and each is made from a separate mixture of ingredients, so the cook — the scientist — can try many combinations of ingredients simultaneously. The ordered array helps keep the recipes separate.

Each small rectangle on this laboratory cookie sheet is a mixture of chemical elements similar to those present in so-called high-temperature superconductors. These remarkable materials conduct electricity without losses due to electrical resistance, and they have caused us to rethink what might be possible for the efficient transmission of energy. The high-temperature superconductors function at tempera-

tures much above those required for conventional superconductors, but they still operate at temperatures below that of liquid nitrogen — much too far below room temperature to be broadly useful. New superconductors, perhaps operating closer to room temperature, might be formed from an enormous range of different elements: there is no theory yet to guide selection and composition. Since we do not know why one combination works and another does not, we try random mixtures. One key to success is to test large numbers of combinations efficiently.

The strategy of trying multitudes of experiments in miniature is new. It is being widely practiced in the development of new drugs. Analogs of this strategy, which is often called combinatorial synthesis, are widely used to select single microorganisms from large numbers that have been forced to mutate in the hope that they will develop useful properties. Randomized, parallel experiments may increase the efficiency of research by allowing one researcher to conduct multitudes of experiments at the same time, and by decreasing the expense of disposing of completed experiments.

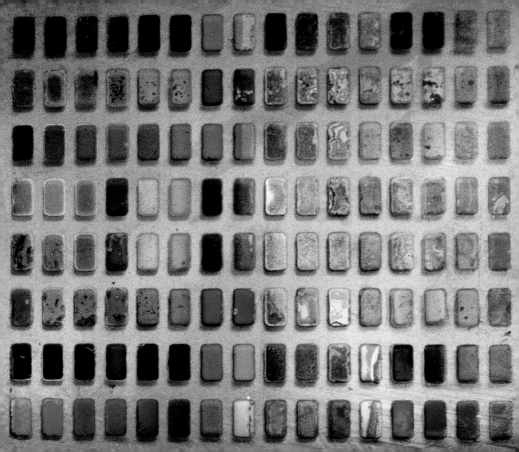

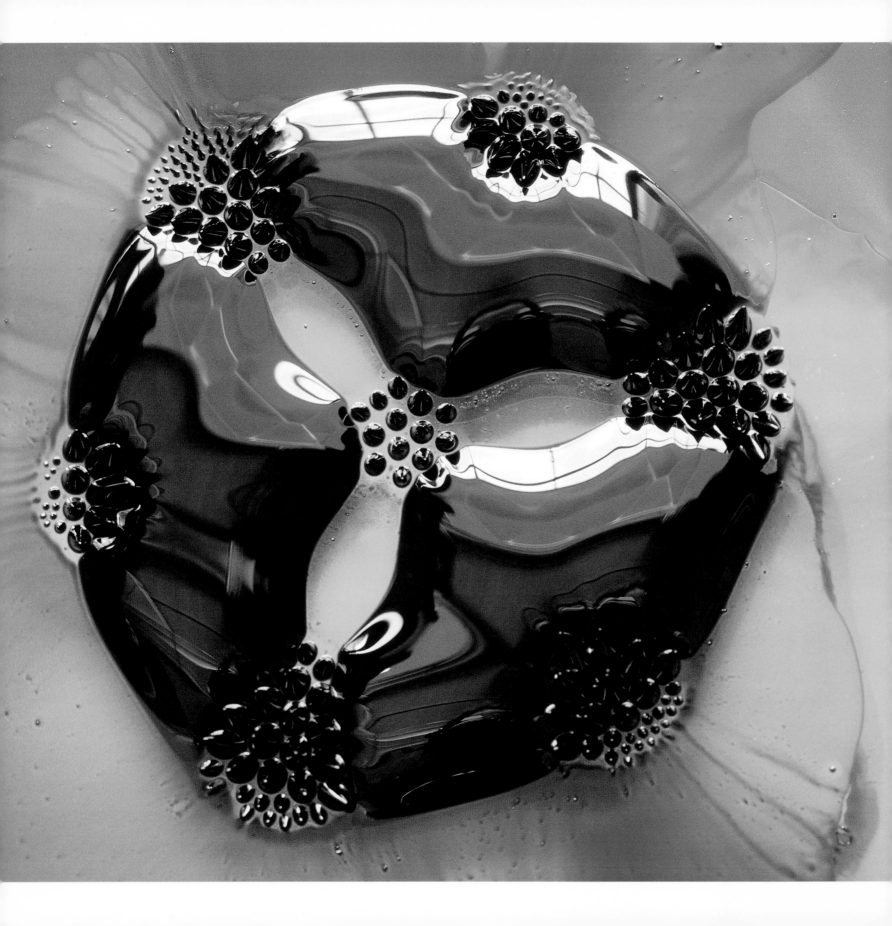

Pity the gryphon, the mermaid, the silkie, the chimera: creatures assembled of incompatible parts, with uncertain allegiances and troubled identities. When nature calls, which nature is it? When instinct beckons, approach or flee?

A ferrofluid is a gryphon in the world of materials: part liquid, part magnet. It is prepared by grinding magnetite—the magnetic lodestone—in an oil. The grinding must be "just enough." If the particles of magnetite are too large, they remember who and what they were and behave like a fine magnetic powder, clumping and settling rapidly from the oil. If they are too small, they no longer show any of the wonderful cooperation between groups of atoms that is required for magnetism. If they are just the right size—if they are small enough that they are not so different in size and character from molecules of liquid, small enough that they have begun to lose their magnetic heritage, but still large enough that they again become fully magnetic when placed in a magnetic field—they develop a useful schizophrenia. Outside a magnetic field, they are non-

ferrofluid

magnetic liquids; in a magnetic field, they become magnetic. Grinding is carried out in the presence of soap, which coats the small particles with an oil-like surface film and makes it even more difficult to distinguish them from the oil. Properly reduced in size, and correctly coated, the particles remain dispersed and do not settle.

When placed in a magnetic field, the conflicting attractions of gravity, magnetism, and surface tension shape the ferrofluid. This drop of ferrofluid was placed on a glass sheet with yellow paper underneath for photographic contrast. Six small magnets were placed below the paper. In regions of high magnetic field, the fluid broke into spikes, trying to imitate the way iron filings line up in columns in a magnetic field. In regions of lower magnetic field it remained a liquid, forming flat drops in a compromise between the siren call of gravity and its own cautious cohesion. The result is shapes seen nowhere else in nature.

The unique properties of a ferrofluid—a stable liquid that responds to magnetic attraction—make it useful in devices where fluid properties and resistance to gravity are needed, such as rotary seals in disk drives for computers, and dampers for high-performance audio speakers.

57

small machines

PREVIOUS PAGES

Mechanical things have a comforting size about them: automobiles, vacuum cleaners, and toaster ovens are the domestic animals of a world drifting out of contact with living things. They thump and chirp and bang in familiar ways; they pull and push and pump and carry. They are the sounds and activities of our barnyards.

Electronic things are disconcerting: small, and more arthropod than mammal. Their buzz is too shrill to hear; their tasks we might wish not to imagine; their forms are not instinctive. If they think, they think thoughts that are not ours. At least they do not move: we have them pinned in place.

This structure is a microelectromechanical system, a MEMS. It is a hybrid between a machine and a microelectronic device—a machine the size of a few transistors. MEMS are one of the next steps in the evolution toward the microscopic that is causing many of the tools of the world to shrink and disappear before our eyes. MEMS are new companions for us. Individually,

some are too small to see. They are mouths chittering sounds we will never hear; eyelids blinking to observe worlds that would be dwarfed by our retina; scribes writing script that only electrons read.

The evolution of these very small machines has been remarkably rapid. This structure is carved from silicon using techniques developed to make microelectronic devices. It is a part of a small gas turbine. Although this device will only rotate when completed, and its cousins can bend and flex, all are still tied to the silicon chip from which we carved them. Future generations will move independently.

MEMS are now used to detect sudden decelerations in automobiles—as in a collision—and to set off airbags. They are parts of analytical systems that have the spatial resolution to locate single atoms. They are being developed for many new applications: arrays of micromirrors for large-panel display systems; tools for fabrication of microelectronic devices; even miniature inertial guidance systems.

60

The lacquered surface of a Chinese tea chest was much prized by our grand-mothers. Many coats of lacquer, patiently polished between coats, produced a hard, lustrous finish with no surface roughness. It required patience, effort, and time.

So it is with the oyster and the pearl. To the oyster, the seed for the pearl is a serious matter: gravel in the eye, a knife in the gut. The oyster has no fingers to pull the irritant out. Instead it carefully covers it in layers of glistening nacre. No Chinese chest was ever lacquered with greater care.

And why is it a shimmering, translucent white? It is the easiest thing for the oyster to do. A pearl in our hand is white for the same reason as snow in sunlight, or the tops of clouds, or frosted glass. It is made of many small transparent particles; those in pearl are held in place with transparent "glue." Each surface in this pearl—like each facet on a snowflake, or drop of mist in a cloud—reflects light. The light enters this maze of mirrors and bounces randomly from facet to facet: much of it ultimately bounces out again. The light at the center of a pearl must be as dim as that at the bottom of a heavy cloud.

The surface of the pearl does not irritate the tender membranes of the oyster. We have similar needs to make foreign objects compatible with our bodies: for implanted heart valves, blood vessels, and lenses, and for replacement veins and bones and teeth. Pearl and other solid structures that are innocuous to living tissue are models for the structures that will prop us up as we decrepitate.

pearls

order

order

forms the spine of our
efforts to measure, control,
and understand.

Order is repetition, regularity, symmetry, simplicity. It forms the spine of our efforts to measure, control, and understand. We recognize and admire the simplest kinds of order in nature — the intersecting planes of crystals and the smooth curves of liquid drops. The order of more complex structures — sea shells, zebras' stripes, opal — fixes our attention. When there are no simple symmetries, order is more difficult to perceive. The living cell is the grand example.

We pay in effort and energy to impose our order on the natural tendency to disorder.

To keep sheep, you need fences; unfenced sheep spread, wandering after grass.

These colored squares are drops of water. They rest on a surface across which they would normally form circular drops and spread until they coalesced. Instead, they are performing unnatural acts: forming squares, staying in place, not mixing. What fences pen them? What grass attracts them?

The surface beneath the drops has been coated with a single layer of molecules of a type much loved by water (a hydrophilic surface). The water molecules cover it as completely as they can. But the surface has also been broken into square fields by painted stripes a single molecule thick of a different type of molecule, one the water avoids (a hydrophobic surface). The molecules of water crowd to the edges of these stripes, but they do not jump them.

The backs of sheep are often spray-painted to identify them; the colors show when part of a flock has found a gap in a fence and drifted into another field. Dyes added to these drops do the same for water.

The square drops are approximately 0.4 centimeters across; the stripes dividing them are 1 micron across and one-thousandth of a micron high. If the water molecules were sheep, the fence would be 3 sheep tall and 1,500 sheep across, and the sheep would be piled 1 million deep in the center of the field. It would be a peculiar form of agriculture.

Controlling the spreading of liquids on surfaces—the wetting of the surface by the liquid—is surprisingly important, not only in painting, printing, and gluing, but also in growing mammalian cells; in fabricating the myriad microelectronic devices that swarm around us in computers, cars, airplanes, and air conditioners; and in condensing steam in boilers.

square drops of water

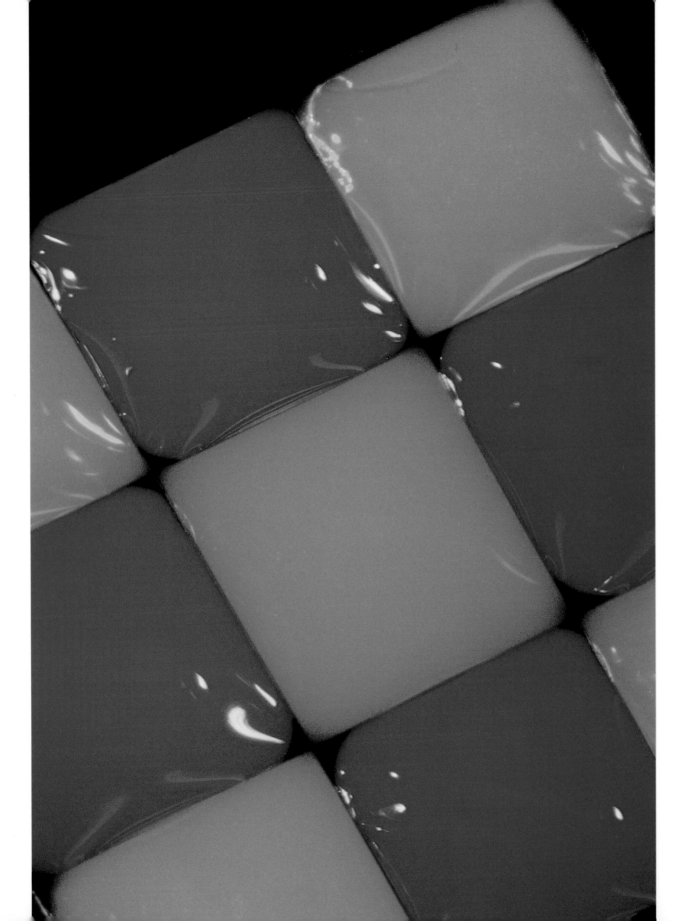

65

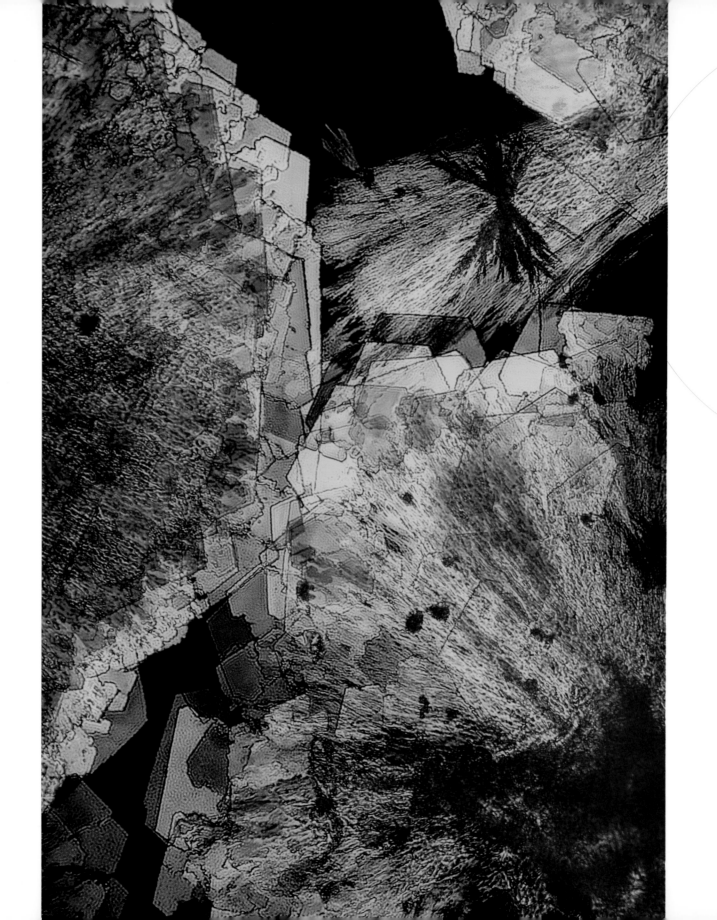

"Crystallization" is identical things arranging themselves in indistinguishable positions, and doing it by themselves. Molecules crystallize; TV sets and dollar bills do not. Being a multitude of identical things is not enough; the members of the throng must also attract each other, jostle into place, and settle into order.

Forming a crystal is delicate: the particles must all have the same shape; they must attract one another but maintain the proper arms-length distance; they must have enough freedom and enough motion to find their most comfortable position. For molecules, this balance of circumstances is common; for larger objects, it is not.

These arrays are crystals of small particles (approximately 50 nanometers in diameter) of cadmium selenide. Crystallization of these spherical particles occurred in sheets; in many areas, the sheets stacked. The crystals of spheres are like opals, except that the spheres are a tenth the size of those in opal. They are a step toward a new type of matter: crystalline arrays of small spheres of semiconductors — materials in which the movement of electrons is more fluid than in electrical insulators, but more hindered than that in conductors.

Microelectronics is based on the unusual movement of electrons in semiconducting forms of silicon; in these arrays light, not bits, is what attracts us. The colors result from several phenomena: the yellow from the emission of light by the particles on illumination with ultraviolet light, the green from selective filtering of light, the red from defects in the crystal.

Each sphere is a "quantum dot": a box in which an electron can move almost from wall to wall without striking an atom. Each "dot" is a drum whose electrons give off visible light when struck with the proper drumstick, ultraviolet light. The timbre and pitch of the drum can be tuned by weak connections to neighboring drums. Quantum objects — dots, wires, boxes, and other structures in which electrons, photons, and atoms are so constrained that they show new types of behavior — are an exotic new continent for physicists to explore. New rules for the behavior of matter will mean new technologies: perhaps more efficient memories and faster microprocessors for computers.

67

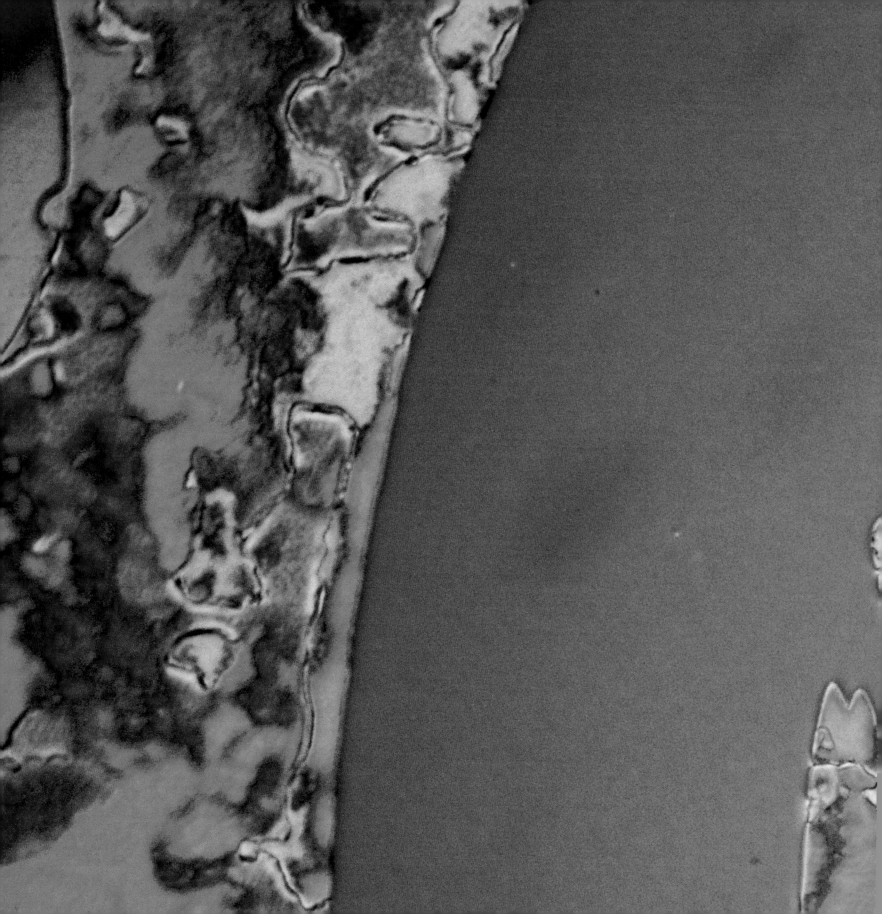

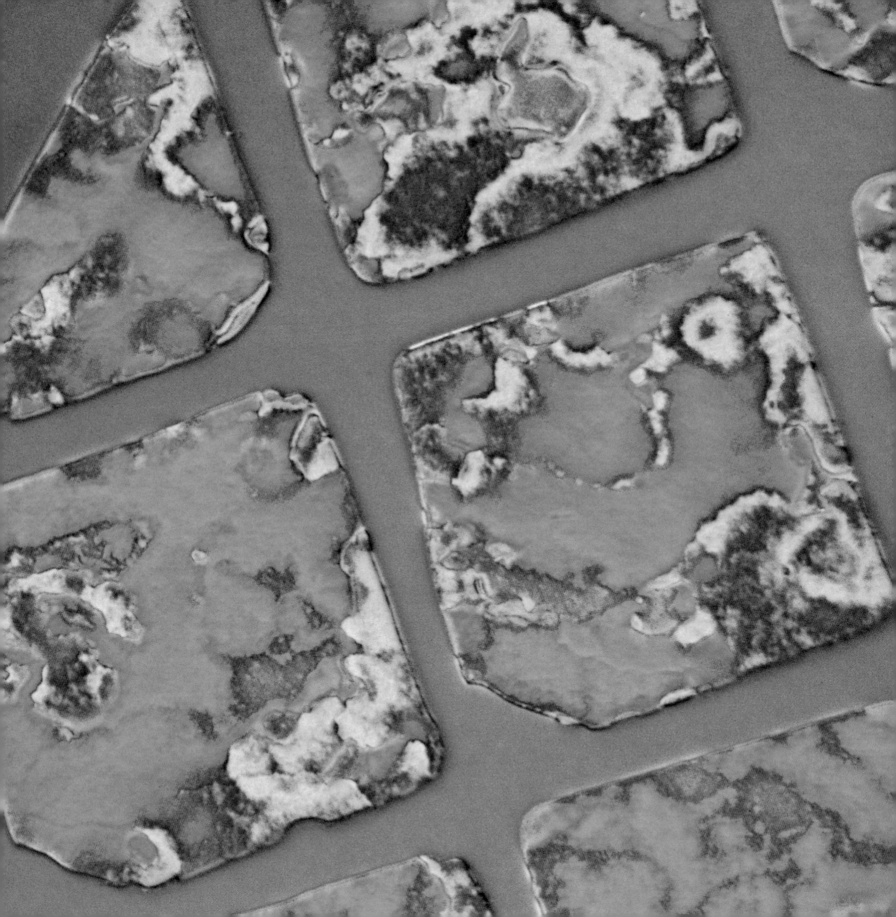

liquid crystal film

PREVIOUS PAGES

We know about gases, about liquids, about crystalline solids. They make up the adults of the society of molecules. The molecules of gases are loners, out of contact except for brief encounters. The molecules of liquids are condensed but disordered: a crowd, tightly packed, jostling and pushing. The molecules of crystals have the order of the military parade ground: identical elements in ordered, indistinguishable positions.

Then there are the adolescents—liquid crystals. Left alone, they swirl in apparent disorder, but they can obey an order as complicated as any followed by their elders. When commanded, they reluctantly line up. When left without external authority, they swirl again according to their own mysterious rules.

And what can they do? At best, their organization is loose; they are not suited for heavy-duty work. In the liquid crystal display of your watch or computer screen, they jostle light. In these devices, the liquid crystalline film is sandwiched between two electrical conductors: a metallic film and a transparent film of an electrically conducting metal oxide. When an electrical potential is applied between these electrodes the molecules line up, and light easily undulates through their loosely ordered ranks; these ordered regions are transparent and appear as black because a black backing shows through. Where there is no electrical potential—where the molecules are left without instruction—they collect in groups, and light passing through them bumps, stalls, changes course; the result is white, as the liquid crystalline film becomes "milky" and light scatters.

Here, a liquid crystal film was sandwiched between two surfaces. One instructed the molecules of liquid crystal to line up perpendicular to it. The second was patterned into a grid, with different regions sending opposing instructions: one region told the molecules to stand vertical, the second instructed them to lie flat. When the orders from both surfaces were the same, the molecules of liquid crystal lined up in an orderly way: those regions are brown. When the surfaces gave different instructions, the result was disorder: these regions are mottled. As always, with adolescents, conflicting instructions led to chaos.

Imagine a world in which there is only order: everything identical—in composition, form, orientation, and motion, as far as the eye can see. Move any distance in any direction, and you cannot tell that you have moved. Such order is deeply disorienting, if change is your guide, but deeply soothing if surprises distract.

With atomic order comes atomic serenity. In crystals, waves of light ripple over mirror-surfaced pools; electrons swim in ordered schools in oceans without tides. Crystals shelter phenomena—superconductivity, lasing—that require calm, coherence, order.

Crystals are essential for many areas of technology: silicon and gallium arsenide for fabrication of microelectronic devices; diamond for cutting tools; sapphire for lasers; quartz for timers for clocks.

70

man-made crystal

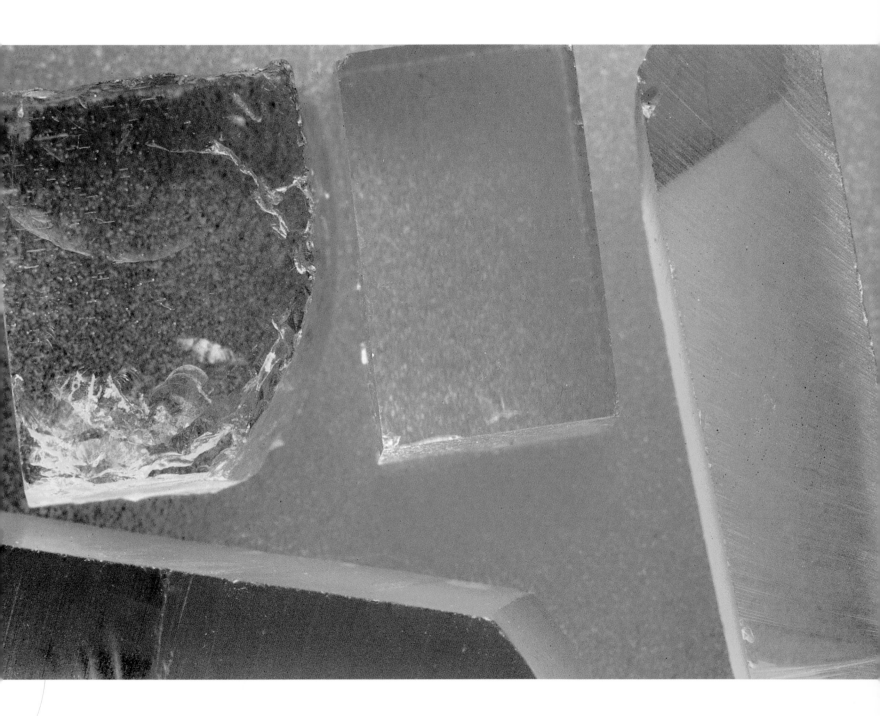

We are a clever species: we can reduce the most complex of our joys and sorrows to blotches of carbon patterned on the bleached tissue of dead trees.

The process is wonderful. We imagine the sound of music. We write the patterns of the imagined sound into patterns of black ink on white paper. Light shining on the patterns evokes a spray of photons from the white surface. The lens of our eye focuses that spray onto the retina, which talks to the brain. The brain translates the conversation into instructions for the fingers. The fingers move on the keys, and the hair cells in the ear's cochlea dance as the strings vibrate. The brain listens, and finally we hear the music.

Many types of symbols on surfaces — from cuneiform to magnetic bits, from painting to musical notation — have immortalized our thoughts, at least for a while. Establishing the most efficient ways of representing information — music, sound, payrolls, simulations of stars — makes the manipulation of that information more efficient.

sheet music

player piano roll

We used to do much of the work of the world together with animals: the ox pulled the plow and we guided; the horse ran the mail and we rode. Now, many of the animals have been retired, we have become managers, and most of the workers—the movers and flyers and diggers and welders—are machines.

We and animals and machines are different. We talk to our own species with words, and we talk to animals with whistles and petting and blows. How should we talk to machines?

We have tried many languages: this was an early written language and involved touch. The machine, a player piano, had fingers: we wrote instructions to it with holes in a roll of paper into which these fingers fit. A hole corresponded to a note; the position on the roll was the time to play the note. This language was like Braille, patterns of dots to code meaning.

The language of the player piano was cumbersome; it was slow, and had a limited grammar. We must evolve simple, clear, and fast languages to use in talking with machines if they are to be skillful workers. The simplest current alphabet for these languages has only the two "letters" of the binary code—0 and 1—the alphabet used by all computers. The grammar and syntax of future languages will depend on the machines we address.

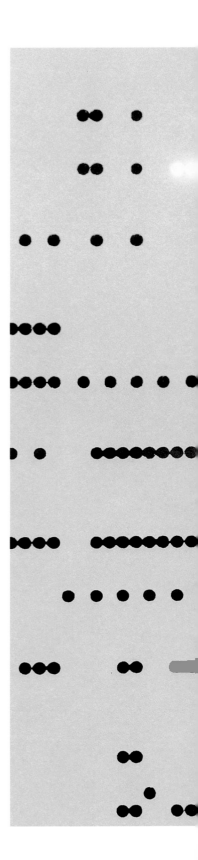

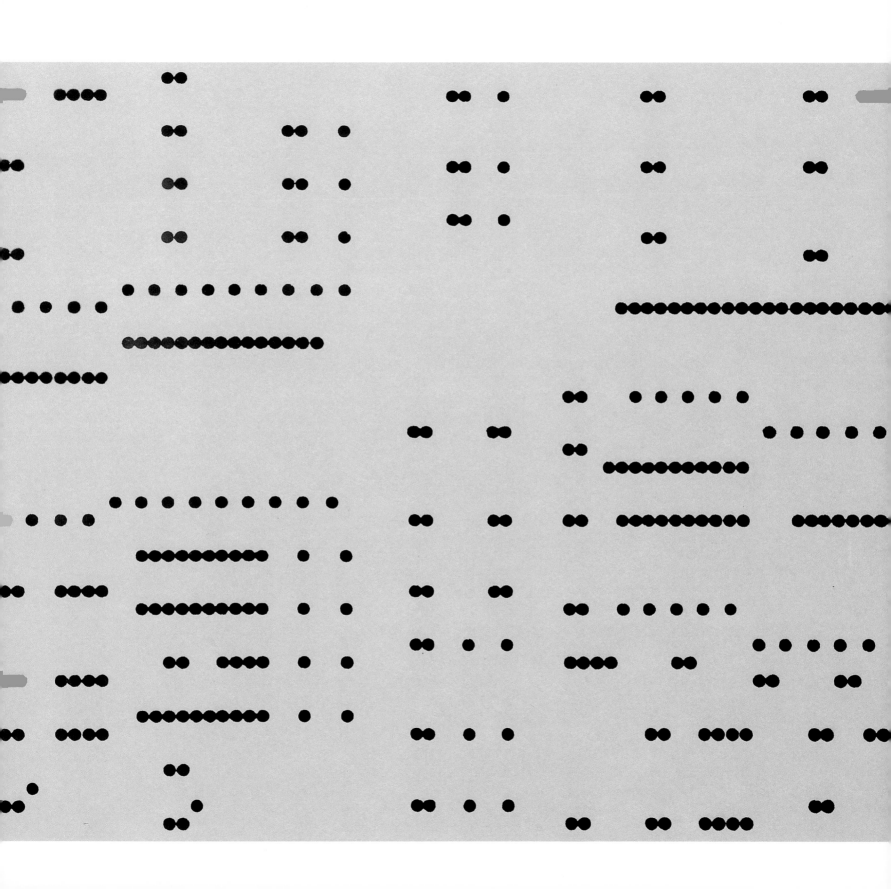

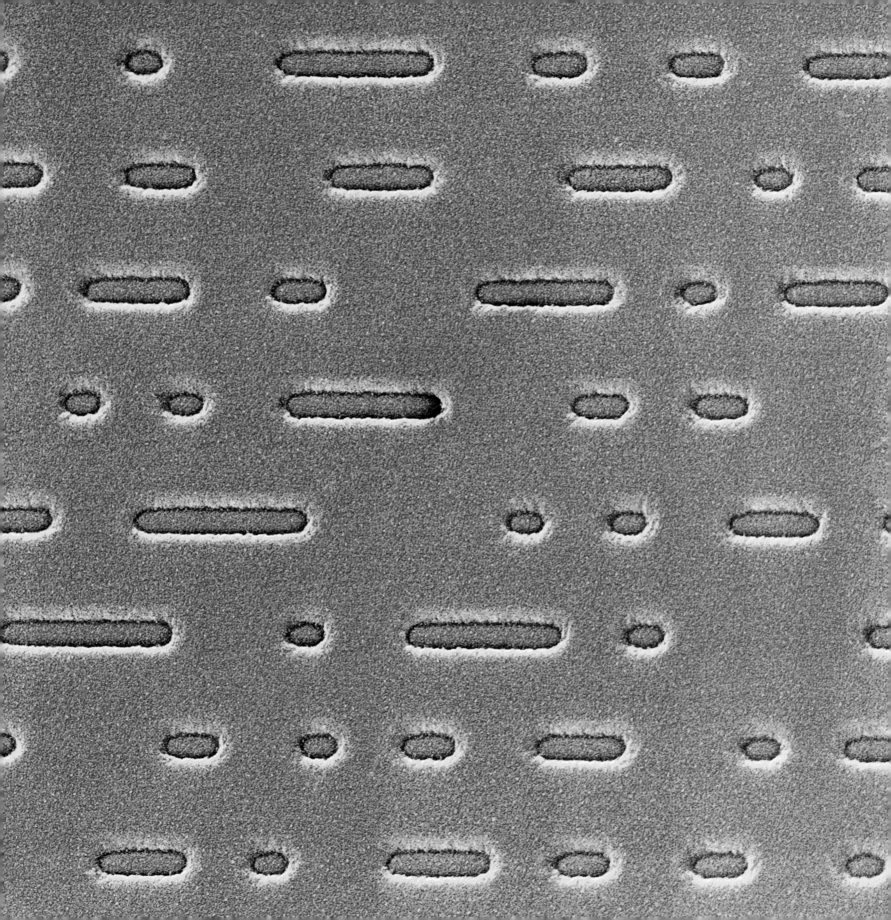

These pits are Braille for light.

The simplest alphabet is "binary code"—dots and spaces (the absence of dots), which can serve for all the letters and numbers—1 or 0, "yes" or "no." The binary code's combinations of 1 and 0 can spell out thought as clearly as the most elegant calligraphy.

The combination of eye and brain with which we read our world is a most remarkable system, capable of astonishing feats of recognition. Faces, moods, coming changes in the weather: a glimpse recognizes all. By comparison, a CD player is a one-eyed robot working in the dark with a head lamp: a simple red light illuminates the spinning disc; a simple, unblinking eye looks for reflected red light. If there is no pit, the light reflects; if there is one, it does not. Any information that can be coded by letters or numbers can be translated into the 1 and 0 of the binary code. Each letter and number is represented by a sequence of bits: the number "5" is "101" in binary. *The Well-Tempered Clavier* becomes a numerical record of the amplitude of the pressure exerted by the sound waves during performance on the recording microphone.

The challenge in a simple job is to do it fast, without making mistakes. CD players succeed. A beam illuminates the disc, and a photoreceptor registers the information faster than any human eye can appreciate, but there is no appreciation of style: just 1001011011001. *The Well-Tempered Clavier* and Led Zeppelin are both ruby glitters from a spinning disc. The light brushes the pits with the gentlest of fingers, and with no physical contact there is no wear.

Our appetite for stored information is voracious and largely unconscious. Learning how to make the pits smaller, and how to generate blue light rather than red (blue light has a shorter wavelength than red and needs a smaller pit as a mirror) are presently problems in the technology of storing information so that it can be read optically. By simply changing from red to blue light to read the disc, and by decreasing the spacing between the pits accordingly, it will be possible to store four times as much information per disc.

compact disc

The diamond in the wedding ring is carbon, crystallized in a world of heat and pressure so extreme that we can not imagine it. Were we to be placed there—the better to observe and understand—we too would become diamond.

Diamond is now manufactured as well as mined, and the diamond mines are no longer the sources of unique treasure that they were. The newest process for making diamond is startlingly different from nature's method. The carbon starts as gas—the same used to cook hamburgers. A hail of electrons breaks the gas into hydrogen atoms and carbon-containing fragments, some of which condense with one another and with the surface. This process coats the surface with tar, but even as the tar forms, parts of it are burned away by the atoms of hydrogen.

Formation and destruction compete, and at the end, only the substance that best resists attack by the hydrogen atoms—diamond—remains.

Diamond is the hardest substance, and the best conductor of heat. It also has no affinity for electrons: if added to diamond, an electron slips off effortlessly if beckoned by any positive charge. The grip of diamond on electrons is the tenuous grip of grass on fog.

These patterns are grids of small holes in silicon that have been filled with diamond powder. Electrons are pumped from the silicon onto the diamond; once there, they stream off smoothly toward a positively charged electrode. The arrays of holes are rectangular shower heads spraying electrons. These sprays can be used to generate light, and they may be used in new types of display systems bright enough to be seen in full daylight.

diamond electron emitters

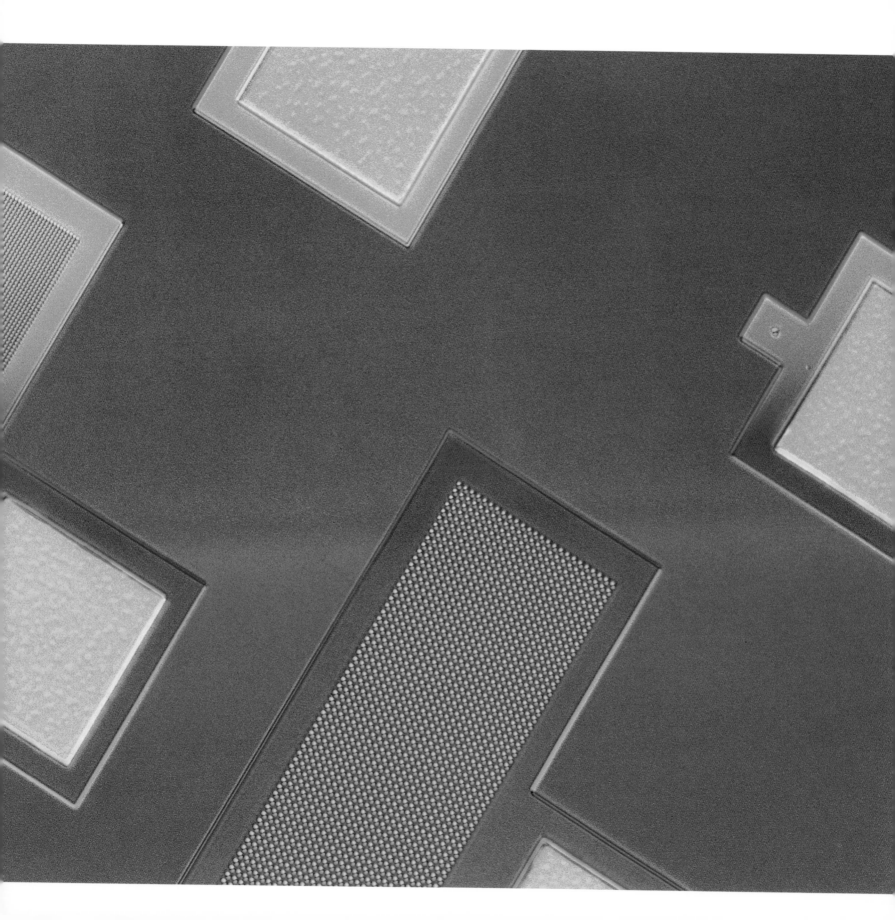

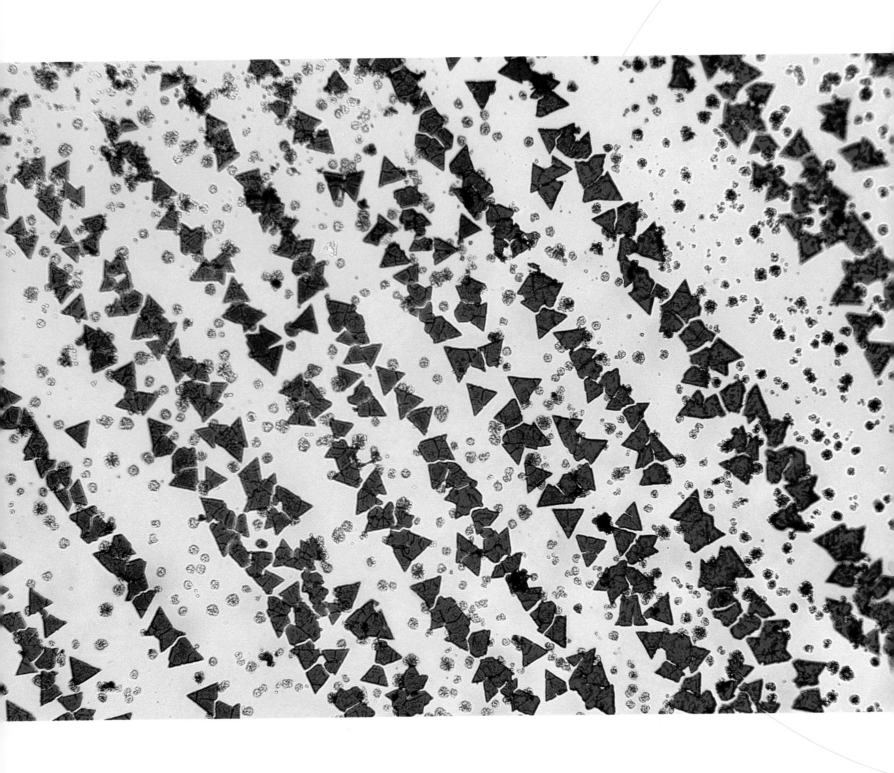

nucleation
of crystal growth

Crystals function unseen throughout our world. The performance of electronic devices rests on the purity of crystals of silicon and gallium arsenide; the time displayed by a watch is calculated by counting the remarkably constant vibrations of crystals of quartz set in oscillation by an oscillating electrical voltage; many lasers use inorganic crystals to generate their light; the safety and ease of handling of drugs is often highest when they are crystals; salt and sugar for the table are crystals; crystalline inorganic materials are the basis of assays used in the analytical laboratories that monitor the composition of everything from food to blood.

Growing crystals and growing plants share common stages: first there are seeds, then the crop, and finally the harvest. In spring, when the conditions—

temperature, sunlight, water—are right, seeds germinate together and grow into plants of similar size. These red crystals have grown to a similar size from solution. Here, the furrows were microscopic cracks present on the surface of a glass container; their rough surfaces provided a complex texture on which the components of the crystals first clumped. Some of these clumps became the "seeds"—the nuclei around which the crystals grew.

These crystals were a lattice of colloid particles: very small clusters of atoms. Each cluster was a core of positively charged cadmium and negatively charged selenium atoms, and a protective shell of organic molecules. First, these small particles were prepared as a thin suspension—a soup—in a liquid. Their aggregation into crystals then

proceeded in two steps. At first, when the soup was dilute, few colloid particles settled onto the surface of the cracks. As the liquid evaporated and the soup concentrated, the likelihood that particles would find the crack increased, and the number on it grew. Eventually, the time was right: the soup concentrated enough to generate seed crystals, and spring arrived! The particles on the surface found themselves in groups—entirely by accident—that were big enough to be recognizable as sections of the lattice of the crystal. At that point, the second stage began: the seed crystals grew to visible size as more particles of colloid attached to them.

Growing crystals remains one of the arts and mysteries of science and technology. Although we understand the theory of nucleation and growth in general terms, producing good crystals is often intractably difficult. Growing high-quality crystals may be the most difficult step in creating a new technology.

analysis of DNA

When game animals are driven through the brush by hunters, they emerge by size. First come the small ones— weasels, rabbits, foxes—that scuttle and slip and weave among the branches. Then come those of medium size— pigs, goats, deer—that pick their paths more carefully, trying here and there. Finally come the large animals—elk, bear—that must force their passage.

These patterns show molecules of DNA that have been driven through molecular brush: a thicket submerged in water. The process is perhaps more like driving eels than four-legged animals, but the principle is the same: the DNA is the quarry, moving by size.

The thicket is a gel, a loose mesh in which the strands are long, string-like molecules knotted into a three-dimensional net and suspended throughout a pool of water. The molecules making up the mesh are chosen to give a net with holes of the right size to obstruct large molecules of DNA, but otherwise not to interfere with it. All the DNA is initially placed at one end of the pool. The molecules of DNA have a negative charge. When a voltage is applied to electrodes placed at the ends of the pool, they swim away from the negatively charged electrode and toward the positive. The smallest molecules do not even notice the mesh: they simply stream straight ahead. Those of medium size slow down: they wrap around occasional strands briefly, but soon they undulate free and move on. The largest molecules entangle badly and move ahead only slowly.

Each band shown here is a collection of DNA molecules of the same size. The separation of molecules of DNA by size is the basis for almost all procedures for genetic analysis, used for finding the fathers of children of uncertain paternity; for identifying the dead; for ferreting out criminals; for warning of genetic damage; for typing cancer and detecting AIDS; or for showing that the scallops on the dinner plate were born shark.

82

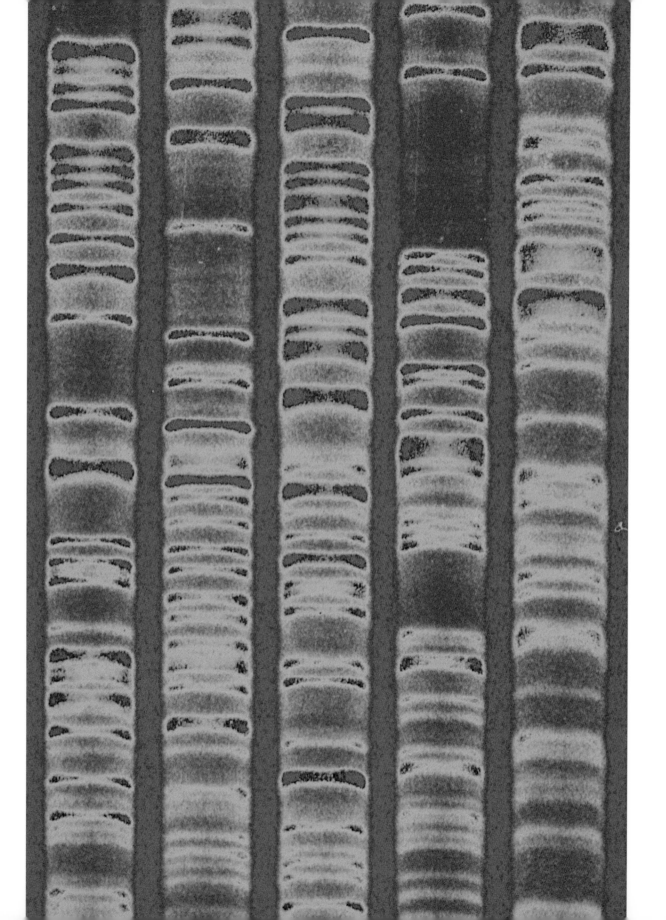

change

We know "now";

we remember "then."

If the two are different,

that is change.

We are immersed in a world of clocks. All that happens meters time. The universe expands, continents collide, we age, leaves change color, the sun sets, children play, we breathe, the wind rustles in the grass.

We know "now"; we remember "then." If the two are different, that is change. Without movement of the clocks— if we know *only* "now" or *only* "then"—time freezes.

Sometimes a thing relates its own history. The trail of a meteor, the bands of an agate, the rusted tool—all tell, at the same time, how it is and how it was.

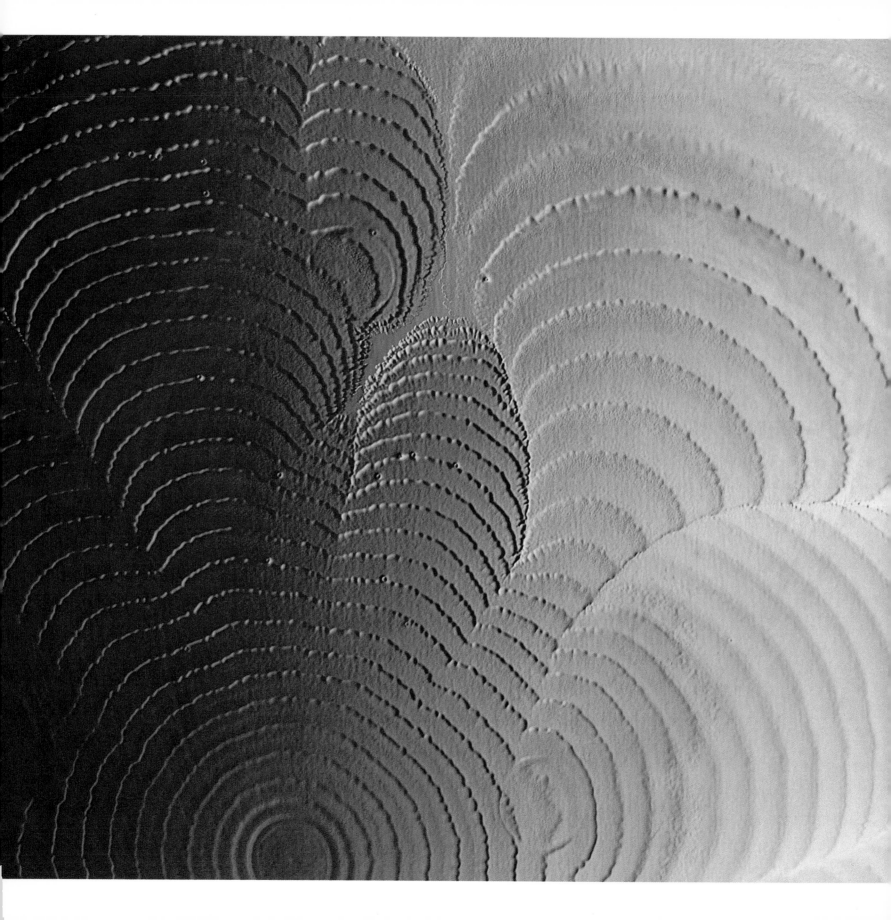

This dish records the history of a civilization of bacteria—the few days that it lasted. The civilization started at the center, when a fresh plate of culture medium—a gel containing nutrients—was inoculated with a few bacteria. They were the first colonists. The population of the initial colony grew, and it depleted the food that was available locally. When the population became large enough, new colonists were sent out. These bacteria flowed radially outward toward more abundant food and uncontaminated space. Following their wave of migration, the colony consolidated its growth in the new region until it reached the critical density in population required to send out colonists again. These cycles of expansion and stationary growth created the patterns here.

The sectors follow the history of particular subgroups of these bacteria. Some families grew to the edge of the plate; less successful families were overwhelmed by the more successful, and they faded. The bacteria could not talk with one another, but they interacted by the chemicals—the "smells"—that they left, and by their influence on the local food supply and the level of pollution. When the food on their continent was exhausted, they died.

From these patterns, we infer how bacteria sense their environment. We sample *our* environment with different and more highly evolved senses than they do, but there are remarkable similarities between their sensors and ours. Understanding perception in all its complexity is one of the great challenges now facing biology. Evolution connects our eyes and nose to the senses of bacteria; their present is our history.

migrating bacteria

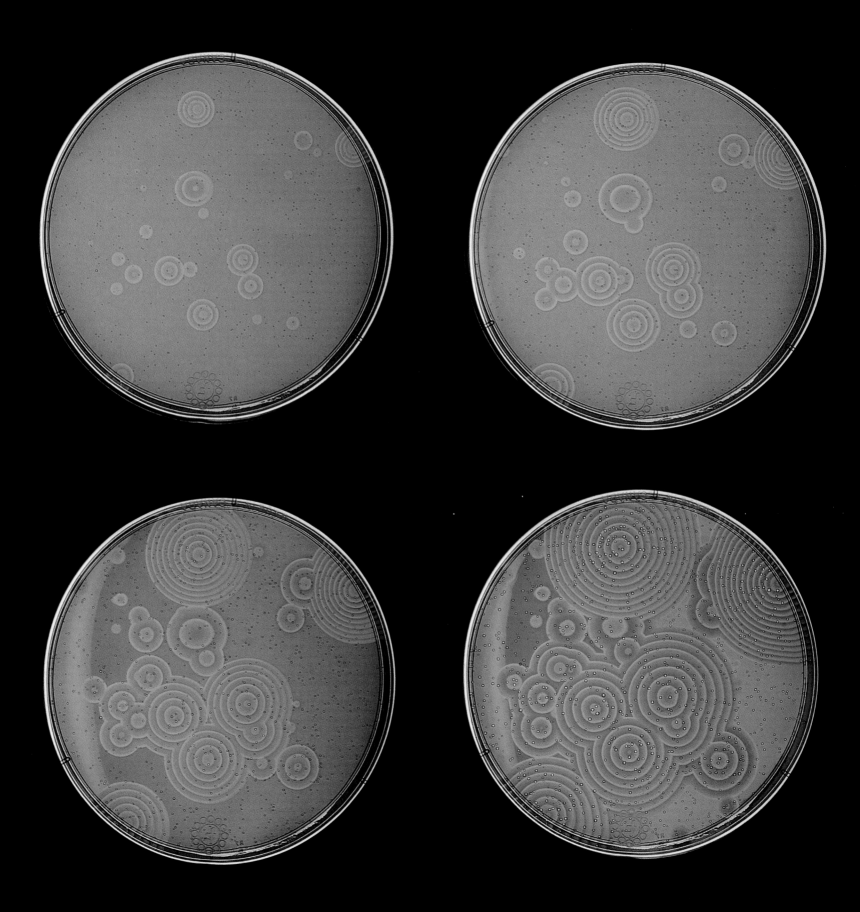

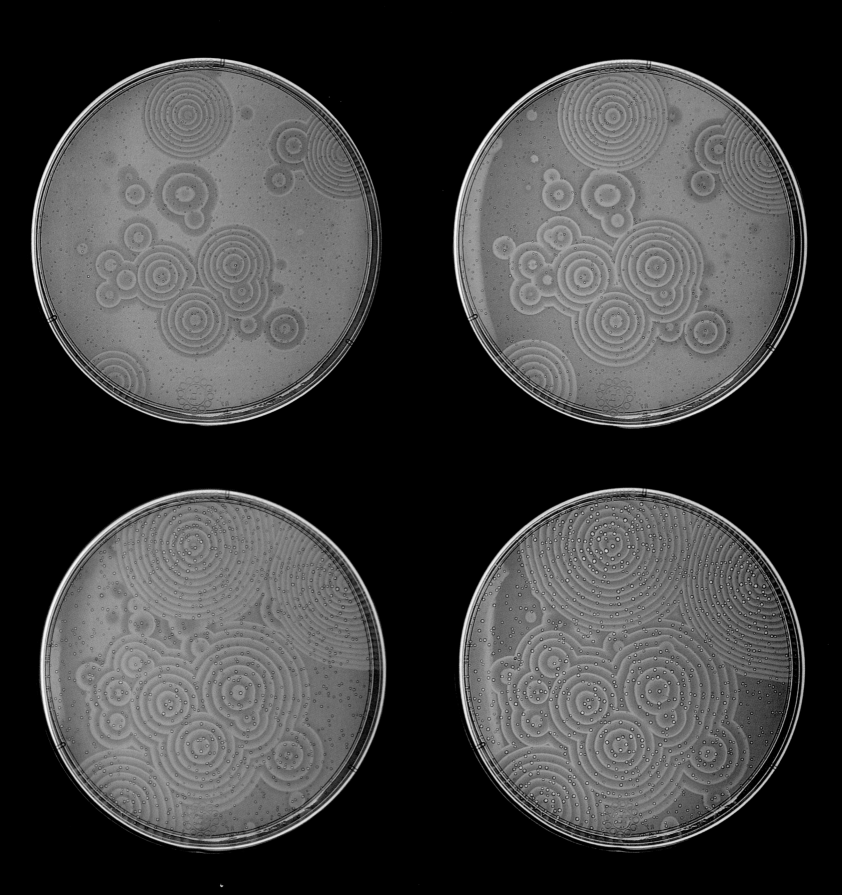

Waves of chemical reaction ripple outward on the surface of a chemical pond. To a stationary observer staring at a point on the surface, the colors—mirroring the concentrations of reactants and products—oscillate. These patterns are startling in their regularity and complexity.

A solution of the reactants was poured into a dish. Reaction did not occur uniformly; it initiated at stationary spots—perhaps on specks of dust, perhaps by accident—and spread as concentric waves. The first product formed in an autocatalytic reaction: the first small amounts of this product that formed accelerated the formation of more of it. The first reaction swept outward, generating high concentrations of the initial product as it moved. A second reaction then occurred that involved the product of the first as a reactant. This second reaction followed the first, destroying the initial product and forming a second. The combination of these two processes—

a wave of the first reaction forming an initial product, and a subsequent wave of the second destroying it—caused successive waves of reaction to ripple outward. An indicator molecule—an observer of these processes—signaled the passage of successive waves of reactions, turning from red to gray as the first reaction took place, and from gray back to red for the second. These images of the same dish show the evolution of these reactions.

The mathematical description of these reactions is analogous to those used to describe predator-prey relations involving wolves and lemmings. First, the lemmings eat grass, and their number grows. The wolves find the abundant lemmings to be a fine supply of food. The population of wolves grows and that of lemmings declines, until there are no longer enough lemmings to support the wolves. The population of wolves then declines, that of lemmings again increases, and the cycle repeats itself.

Oscillation is associated with control, although control is not an important part of the processes occurring here. Steering a bicycle while weaving it back and forth across a line is easy; keeping it exactly *on* a line is difficult. Electronic circuits, chemical reactions, and bacterial metabolism are often most stable when oscillating around an average value—a control point.

These stable oscillating patterns catch the eye (a black and white zebra attracts more attention than a gray pony), and demonstrate how chemical energy can be converted to unexpectedly regular patterns, and how oscillations in time can be converted into oscillations in space. They hint at structure in life—the most spectacular of processes that burn chemical energy and generate complexity. Some of the reactions occurring in simple organisms seem to oscillate, and more complex regularities exist throughout nature: the pacemaker of the heart, the trains of spikes nerve cells use to talk to the brain, the aggregation of slime molds, the patterns in the fur of animals, and the extraordinary geometrical organization that characterizes the early stages in development of an embryo.

oscillating chemical reaction

PREVIOUS PAGES

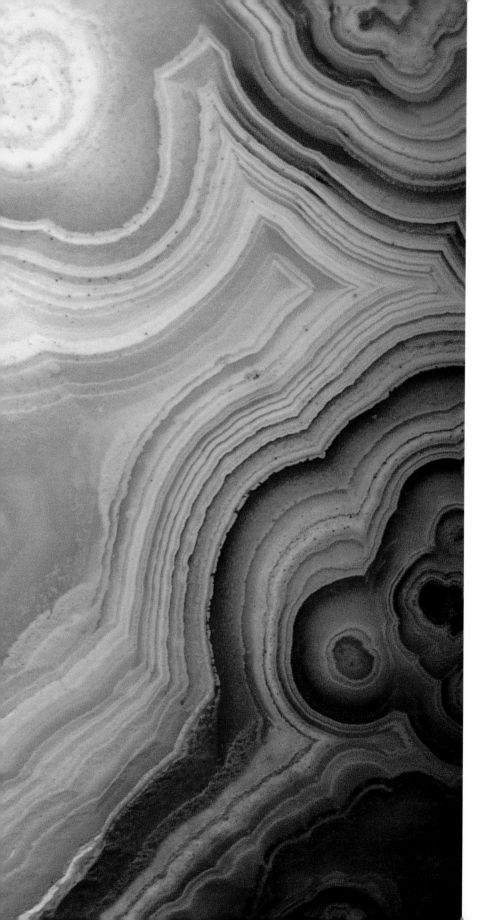

agate

The subtly colored bands of agate and
the layers of accumulated muck that
plug the sewer pipe of a house both
record sludge formation. The pattern
shown here began with a hole in a rock.
The hole filled with water carrying dis-
solved silica—the substance of beauti-
fully transparent quartz—but here it
was contaminated with other dissolved
minerals. As the water evaporated or
cooled, a layer of solid silica coated the
walls of the hole: repetitions of this
process over hundreds of years pro-
duced the cloudy record we now so
admire. The color and thickness of the
bands are a history of the composition
and temperature of the soup from
which they came, and a record of the
geological past.

91

mammalian cells
on a patterned surface

We avoid death. We think of it as an undesirable accident in the plumbing: an artery clogs or bursts; a tumor pushes the machinery out of line; an automobile at the wrong time and place reduces us to mush. Still, proper maintenance forestalls the inevitable, and we are emotionally disposed to live forever.

Many of our cells take the opposite point of view. They are always poised to die, and only constant encouragement from their neighbors keeps them living. Unless stimulated by chemical messages—growth factors—and the reassuring touch of their neighbors, many cells quietly commit suicide. We believe, as a sentient collection of cells, that our normal option is "Live, unless misfortune befalls." For most of our cells, the normal option is "Die, unless instructed otherwise." Sentience denies the inevitable.

Cellular suicide—apoptosis, or programmed cell death—is one of the profound discoveries of molecular biology. Many events can trigger apoptosis in a cell: damage by a virus or radiation, mistakes during replica-

tion, obsolescence, or an abnormal environment. Cancer is, in part, a failure in apoptosis: a cell that should recognize serious dysfunction and commit suicide fails in its duty and multiplies instead.

One of the many questions that a cell asks about its environment to determine whether all is right is, "Am I attached to something?" The normal state of most cells is to be attached to neighboring cells or biological structures: cells that wander are often deranged. The cells pictured here rest on a surface that was patterned by printing; the "inks" used permit the cells to attach and spread only in certain areas. The smallest squares force cells into entirely unnatural shapes: too small, straight edges, sharp corners, no other cells in physical contact. In this uncomfortable closet some cells continue to live but refuse to divide; some commit suicide. Observing these responses clarifies how a cell sees its world and how it chooses among its options. Understanding how cells choose to live or die will, we hope, someday help to control cancer, forestall aging, and regenerate complex organs.

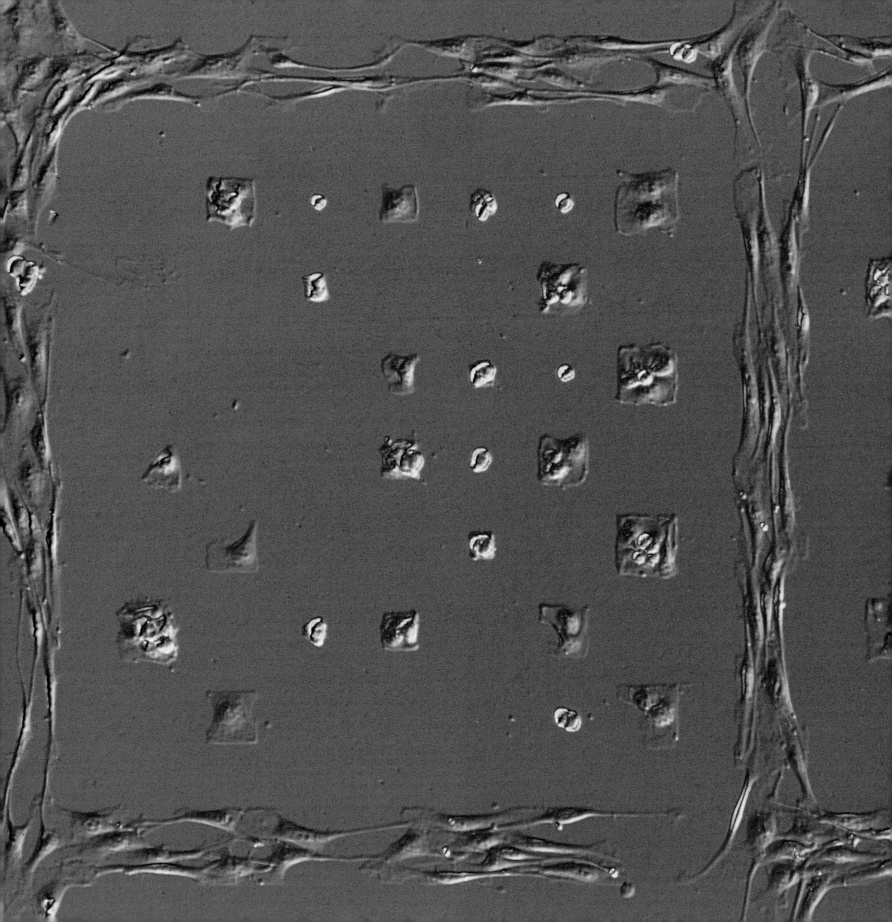

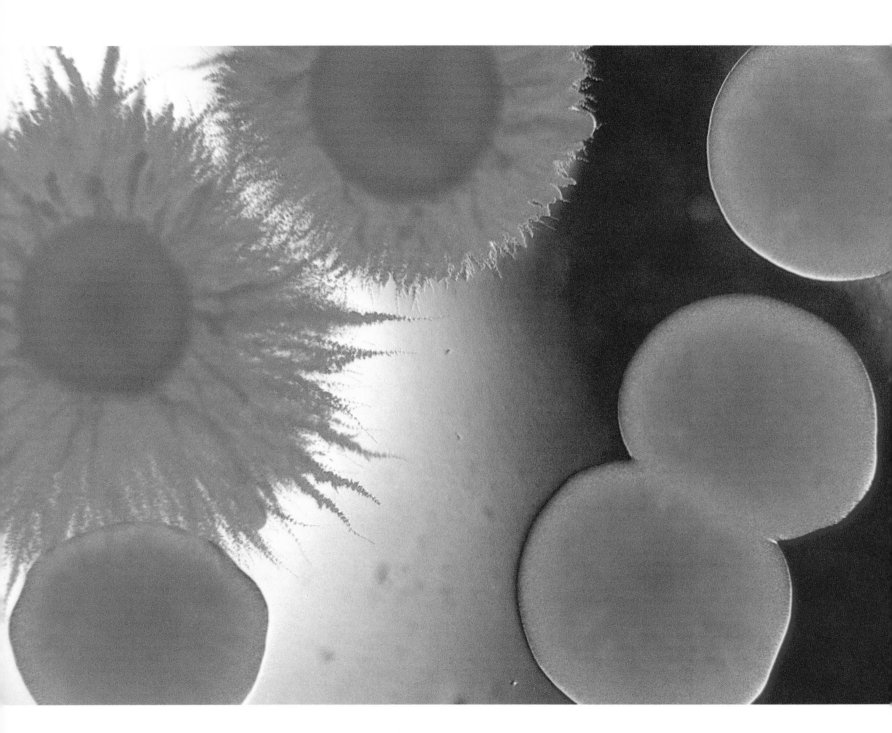

Wars start at borders. A state, once peaceful but now driven to aggression by motivations and provocations that are often obscure, crosses a border and invades the territory of a neighbor.

The relations between a disease-causing microorganism and one of us can follow the same course. These white plaques are colonies of a yeast, *Candida albicans.* This yeast can cause disease— mild in otherwise healthy people, serious in individuals with weakened immune systems due to cancer or AIDS. This yeast exists in two forms. One is smooth, one filamentous; in the laboratory, the smooth type forms rounded colonies on top of the medium used to grow it; the filamented form is invasive and launches spears of connected cells—raiding parties— into the medium. This transition from the smooth form to the filamen- tous, invasive form is associated with disease in humans.

What provokes the yeast to aggression? The signals that cause a smooth yeast to convert to an invasive form are chemicals in its environment; these chemicals are sensed by the yeast using

something like a sense of smell. Detection results in a cascade of inter- nal changes that cause the transfor- mation. Its tendency toward aggressive- ness is hereditary: the molecules that sense the chemical signals are coded in its genes. If these genes are damaged, the yeast no longer responds: it remains the smooth, noninvasive form even in an environment that would provoke a normal yeast to invade.

In this image, the normal colonies of yeast cells have transformed to filamen- tous growth, and the abnormal colonies having defective genes have remained smooth, unable to transform. Under- standing the world of the yeast may suggest strategies for defeating the dis- eases caused by its invasions.

colonies of yeast

Swirl wine in a glass and watch: a film of liquid creeps up the wall of the glass, pauses, collects itself into drops along the top of the film, and slides back down into the wine. The motion evokes the fluidity of whales breaching or the changing shape of fog condensing into rain. It is an astonishing amount of independent activity for a simple liquid: a kind of levitation followed by lateral condensation. It smacks of water running uphill.

The invisible hand that pulls the wine up the side of the glass is surface tension: the tendency of a liquid surface to contract and to minimize the number of its molecules that are at a surface exposed to air. On the wall of the wine glass there is a competition. The solid surface of the glass tries to minimize its exposed surface by covering itself with wine; the pull of the glass on the wine generates a thin liquid film and increases the exposed surface of the liquid. The wine meanwhile tries to shrink its surface.

The competition between stretching and shrinking is complicated by the fact that the wine's eagerness to contract is different at different points. Wine is a mixture of alcohol and water. Water by itself does not tolerate being spread as a thin film—it has a very high surface tension and strongly resists having its surface stretched—but the alcohol in the wine weakens this resistance. The molecules of alcohol at the surface of the liquid attract their neighbors only weakly, so stretching a film of water containing ethanol is easier than stretching pure water.

The alcohol is also volatile: it evaporates from the wine and escapes into the air. This evaporation is most rapid at the lip of the film of liquid that covers the wall of the wine glass, since this lip is closest to the open top of the glass. When the alcohol evaporates, the proportion of water in the remaining wine increases, and its surface tension increases. This wine enriched in water collects itself into drops, pulled together by its increased surface tension. These drops slide back down the wall of the glass into the wine.

Phenomena related to tears of wine are important in many technologies that involve thin fluid films, especially if these films have components with different volatilities, or are exposed to different temperatures, as in distillation, or the spreading of paints containing volatile solvents.

tears of wine

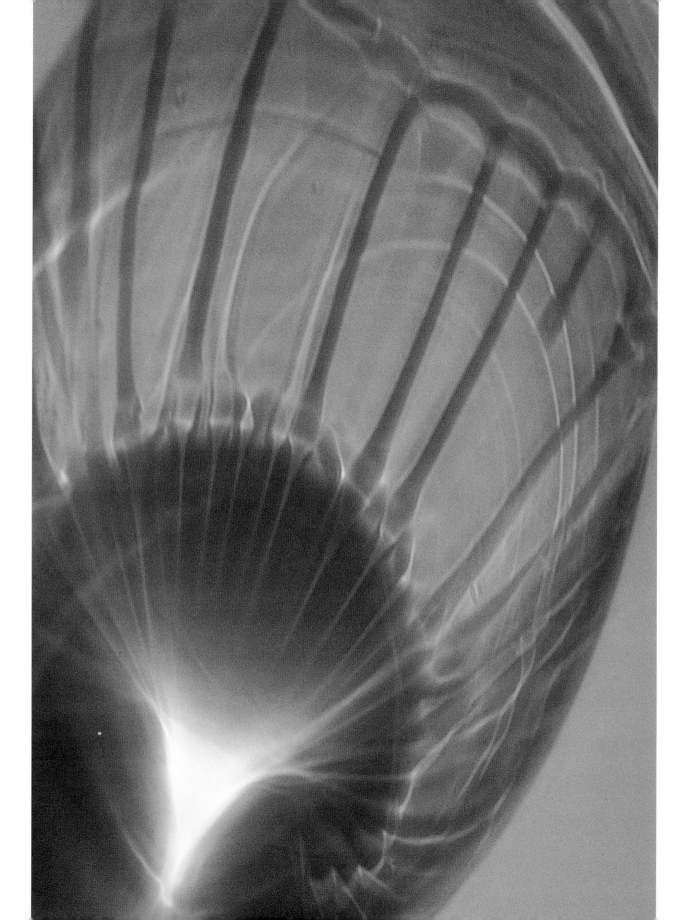

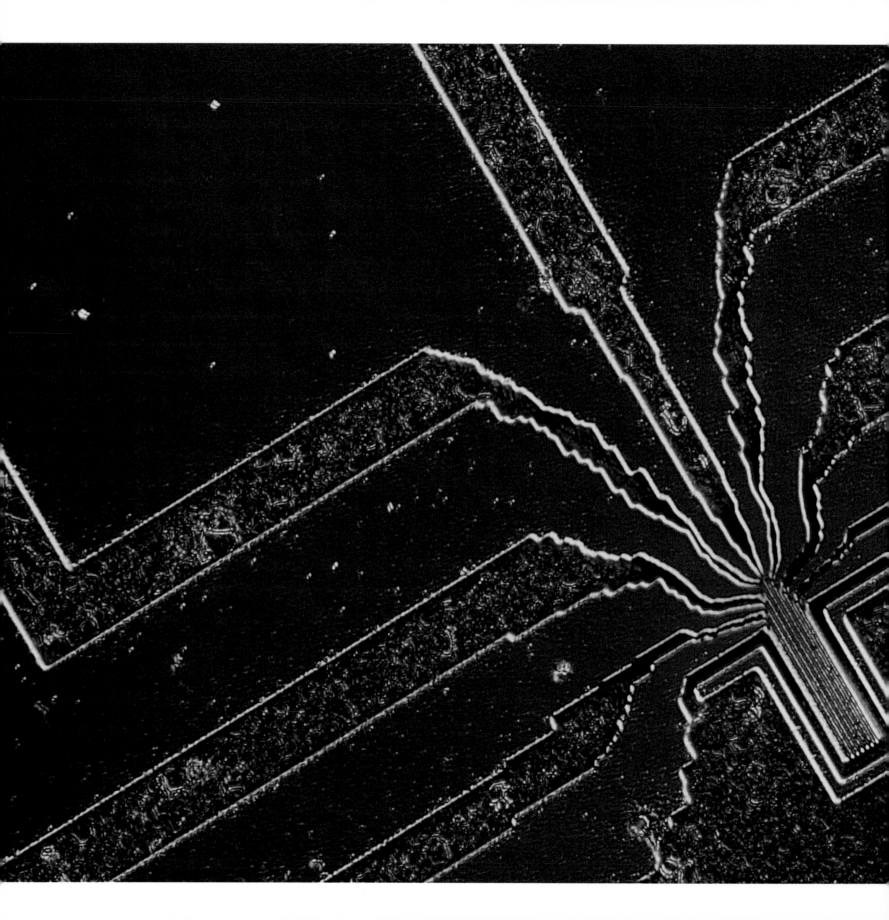

microelectrodes

Electrons know two verbs: *seek* and *avoid.* They seek the positive charges of atomic nuclei; they avoid the negative charges of other electrons. That is almost all they know.

To electrons, a solid metal wire is a hollow pipe through which they can flow. Here, a pattern of small, unconnected wires was immersed in a liquid: in the image, the wires are the flat brown bands outlined in gold. The smallest wires—those with which the experiments were done—are barely visible in the "stem" on the lower right. Electrons were forced into the ends of some of the pipes and sucked from the ends of others. If the pressure on the electrons was sufficiently high in the pipes that were overfilled, they squirted onto molecules in the surrounding liquid.

The molecules carrying these escapees moved randomly through the solution. When they approached one of the partly emptied pipes in their meander-ings, the electrons sensed a vacuum—a deficiency of electrons—and hopped in. It was a kind of children's game for the electrons: crowd into one pipe; hop out onto a molecule in the solution; wander with your molecule; find an "empty" pipe; hop back in; escape.

This lively process is useful for studying the molecules in solution, not the electrons themselves. The movement of the electrons in the wires—the electrical current—is well understood. The amount of pressure in the wire "pipe"—the electrical potential—required to force them out of the pipe and onto the molecules in solution is determined by how welcoming those molecules are and is one way of characterizing them. The time required for the molecules with their electron passengers to drift from one electrode to the second tells how rapidly they move. This information helps those who design batteries and those who use electricity to cause chemical reactions. It may lead to improved sources of portable power for running laptop computers and cellular phones for longer times and for silent electric vehicles contributing little to urban air pollution.

When we die, we leave behind a midden: photographs, bank accounts, letters, clothes, teeth, bones. Whatever patterns the artifacts in these piles of rubbish carry are usually and mercifully lost as they are mixed into the compost heap of time past. Biological artifacts are especially evanescent: as fire eats wood by oxidation, so air eats paper. Librarians even call this process "slow fire."

Shakespeare's signature

We occasionally wish to preserve artifacts that remind us of the famous or notorious. Conserving antiquities—paper, tissue, fabric—is a part of recording history and of keeping our past from being eaten by ghosts. Sophisticated technology now preserves very old papers and fabrics, and establishes their authenticity. In this instance, identification of the signature as authentic is based on a web of evidence that includes measurement of the rate of migration of iron (present in the ink) away from the edge of the line: the distance over which the iron migrates depends upon the length of time that the ink has been in contact with the paper, and helps to date the signature.

disorder

It all ends in ruin.

We design, we build, we conserve,

but the end is always disorder.

It all ends in ruin. We design, we build, we conserve, but the
end is always disorder. We extract order from disorder:
we separate, refine, shape, assemble. What we build, we protect.
But milk and coffee mix in the cup; iron and oxygen combine;
machines wear and fall apart. The final state is disordered,
not ordered; mixed, not separate. Our constructions are
the triumph of effort over the inevitable; their decay is the
triumph of the inevitable.

Mixing — the growth of disorder from order — involves
surfaces. The first signs of disorder, failure, and decay often
occur at surfaces joining unlike things, such as the man-made
and the natural. We observe the processes that lead to
disorder — failure, fracture, wear, corrosion — and learn,
sometimes, to forestall the incursions of chaos.

○ r u s t

To make a new piece of iron — a tool,
or part of a structure — requires
us to spend energy in great quantities:
energy to extract the iron from the ore,
energy to shape it. As quickly as we
are done, the process reverses: very, very
slowly, the iron burns, oxidizing where
it is exposed to air and moisture.

Iron rusts; we decay. We, and iron, and
stars, and the universe itself all move
at our own pace to that inescapable
final state of disorder. We obey few
laws, but one we all obey is the second
law of thermodynamics: Where we
end is where disorder is the greatest.

The process occurs from the outside in:
the oxygen in the air must reach the
metal. The rust forms and falls from
the surface in disorder; the smooth
surface roughens and turns the dark
red-brown color of iron oxide. Lichens
graze in the ruins. The form of the
piece diminishes, and finally, in a
leisurely way, disappears. Rust to rust.

This piece of silicon was immersed
in a chemical ice storm: a fog of react-
ing vapors that condensed as a tough
glassy film on its surface. The film
was intended to keep the herds of elec-
trons in the silicon from escaping,
and to protect them from harm. It was
to have been a secure pen: a kraal for
electrons.

The procedure failed. The film formed,
but it shrank. Instead of sticking to
the surface, it ripped loose and peeled
like sunburned skin. In the rubble
lies instruction. The scholars of this
type of failure look at the fragments
and judge the misfit between the
skin and the surface. The shadows on
the surface hint at the timing of
the breakdown: where there is blue, the
film broke early in its deposition
and new film formed; where there is
white, the film broke late.

The art of building microelectronic
devices is the art of making very large
numbers of microscopic things
perfectly: the gates, transfer chutes,
and holding pens for electrons must be
small, and they must not leak. The
devices operate by moving electrons
from place to place, as a stockyard
moves cattle. The devices are very small,
and the electrons need move only
short distances — a few nanometers or a
few millimeters. Small distances mean
short times, fast calculations, small
quantities of materials, and low costs.

105

mechanical failure of a thin film

FOLLOWING PAGES

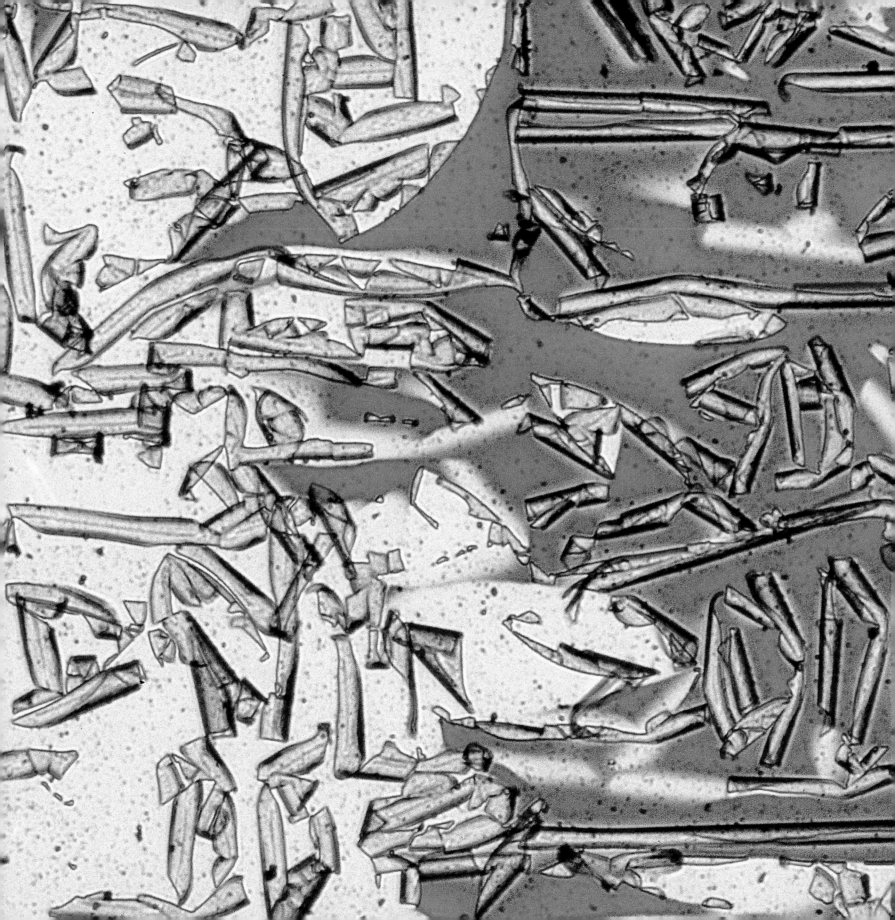

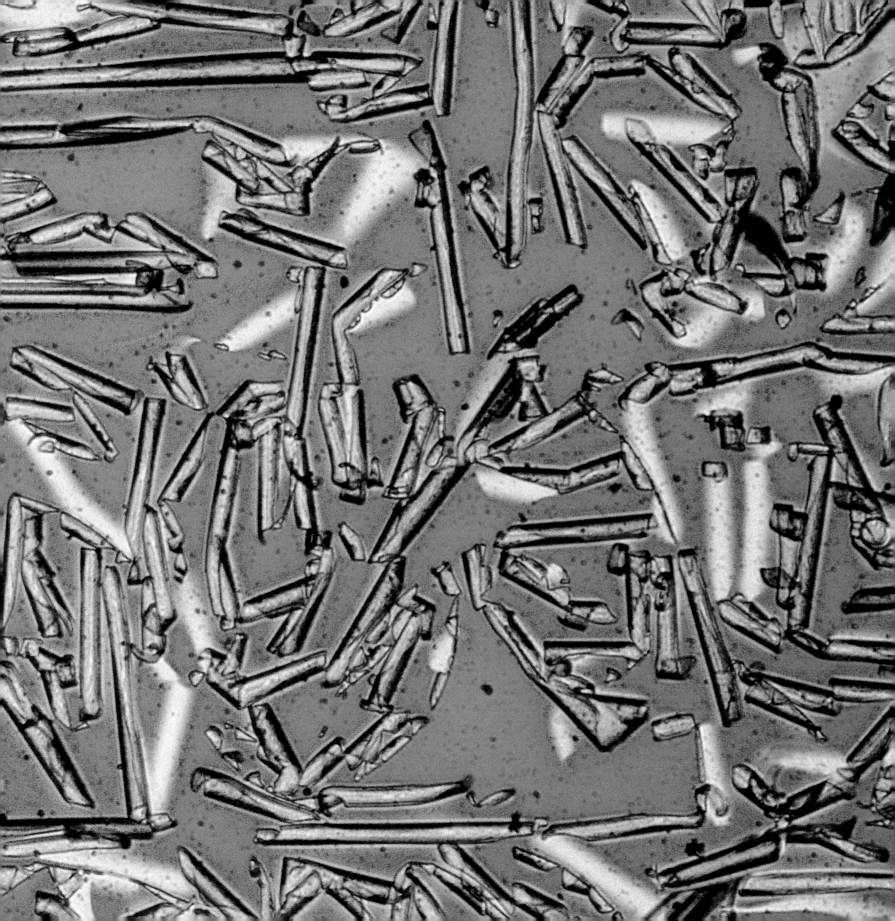

A dam is a barrier that keeps water from flowing freely downhill. A hydroelectric dam exacts a tax from the water as it passes by. It allows the water to follow its natural inclination and flow down toward the sea, but it extracts a price: by the time the water reaches the outflow from the dam, the turbines have drained away some of its ebullience and converted it to electricity.

To be a dam — to stand in the way — is always difficult. Water is never content with the arrangement, and given a chance, it will destroy a dam. First by a crack and a seep, then with a dribble and a spout, then catastrophe — ultimately, the water always wins.

This plastic film was a dam for electrons. A voltage across the film told the

electrical damage in a light-emitting display

electrons which way to go — which way was "down." The tax paid for passage was energy in the form of light: the electrons crossed the film by skipping from molecule to molecule; on one of these skips, as they moved from one kind of molecule to a second, they released a photon.

Then this electronic dam began to fail. First there was a small defect: a crack through which electrons could trickle uncontrolled. As more and more electrons crowded through the crack, it enlarged. The electrons' passage — a surge of electrical current that became a lightning bolt in miniature — punched holes in the dam. These circular spots record the points of failure.

This film is being developed as the light-emitting element of a new type of display for electronic systems. Understanding the mechanisms of failure in these systems is essential to building highly reliable displays.

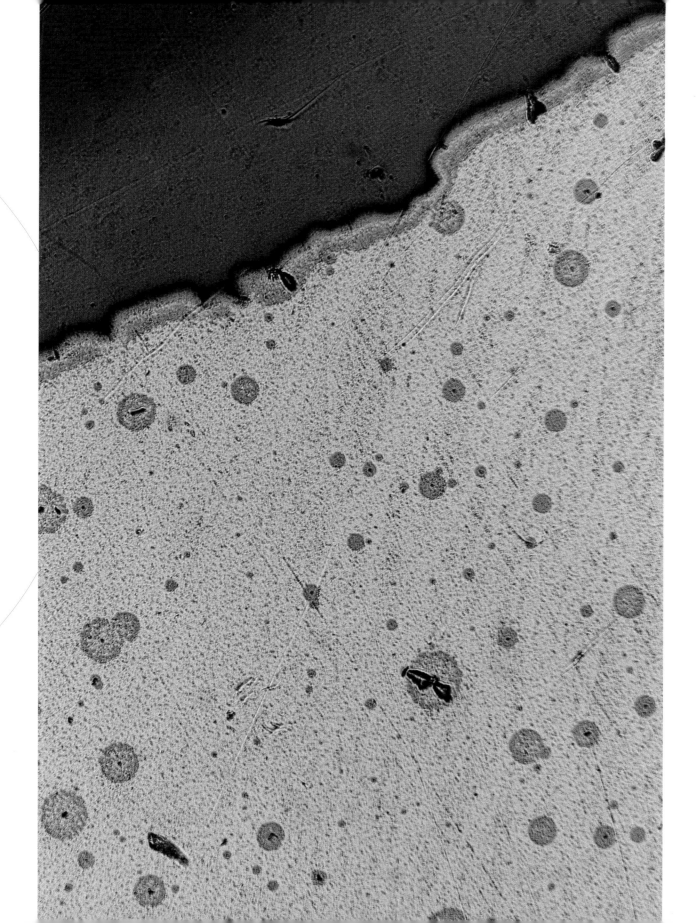

109

Ancient eaters of rock; microorganisms
that patiently digest the most unpromis-
ing of foodstuffs and convert it
into the most unprepossessing of life
forms. To us, the stone columns
decorate an elegant formal garden and
signify the ennobling influence of
culture and the enrichment of the spirit;
to them, the columns are lunch.

All living things must have minerals—
phosphate, sodium, potassium,
calcium—to make their internal
machinery work. We obtain these miner-
als by eating plants and animals;
plants obtain them from soil; lichen
extracts them from the least cooperative
material—rock—and from rain-
water and dust.

Lichens are a cooperative venture:
they are a symbiotic mixture of two
forms of microorganisms: algae and
fungi. The algae harvest light photosyn-
thetically and provide the organic
materials necessary for the fungi; the
fungi produce acids that leach minerals
used by the algae from the rock.
These slow processes erode many
forms of rock and are a subdued part
of the ecology of the planet. They
eat the stones we carve.

columns with lichen

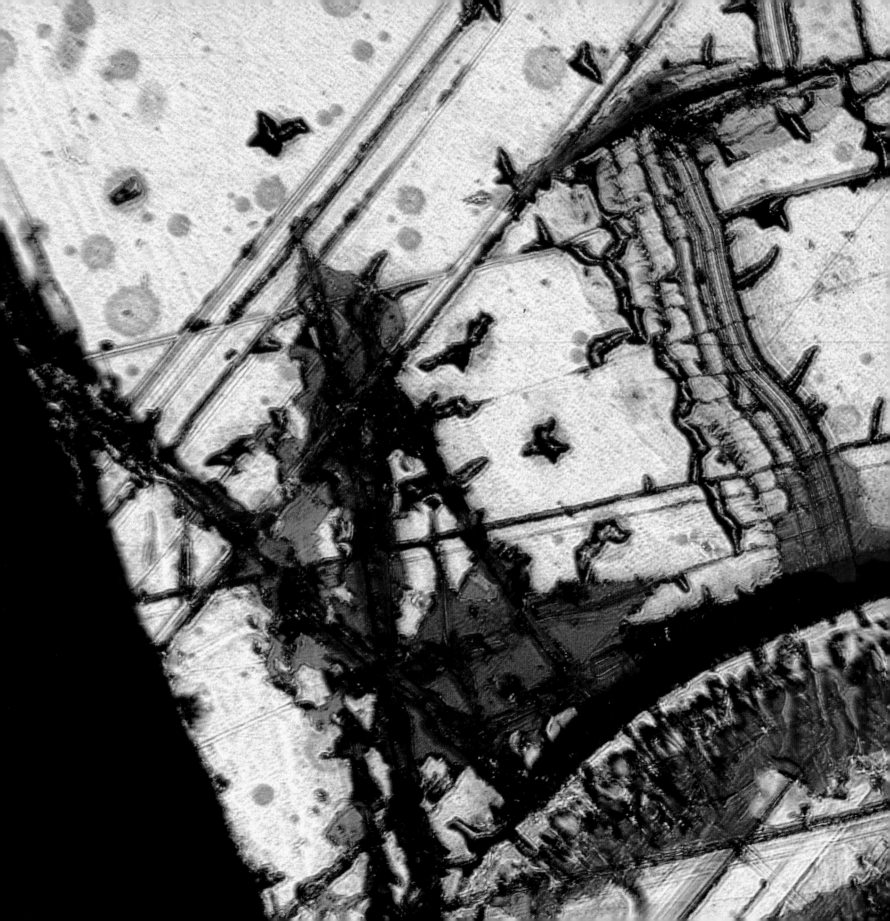

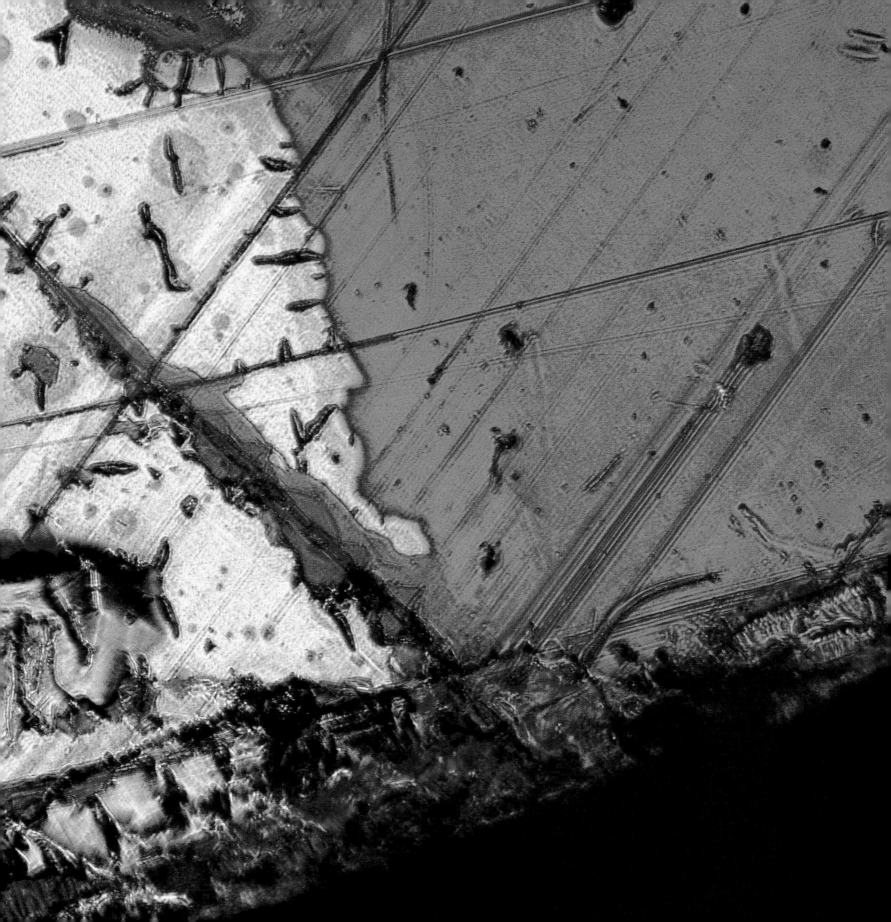

damaged film

PREVIOUS PAGES

Some of the best experiments are accidental: an effort to establish a fact fails, but to the surprise of everyone involved, the failure yields the unexpected and opens a new field. More often, failures are just that. This thin plastic film was intended to provide the light for a flat-panel display. It was damaged during its fabrication. Most of the time, research does not work as planned.

114

A log on the fire burns cheerfully; a telephone book smolders and goes out. Both are wood, but they differ in the way they form ash. As the log burns, the ash falls away and exposes fresh wood to the air and the flame. The outside of the telephone book forms a coherent char, which protects the interior by excluding oxygen and heat.

Copper also burns when hot. This pattern is the surface of a copper plate—the bottom of a pan—exposed to the full heat of the cooking flame. The "ash" from this combustion is a protective skin: as the copper combines with oxygen from the air, it forms a thin film of a new compound— copper oxide—on the surface. This film protects the bare underlying copper, at least for a while.

The formation of protective surface films is critical in materials—metals, plastics, ceramics—used at high temperatures. The hot sections of jet turbines and internal combustion engines must be made of temperature-resistant materials; so must cutting tools, bearings, and brake pads. The ability to resist flame by formation of chars is also crucial in fire-resistant building materials.

oxide layer
on a copper pan

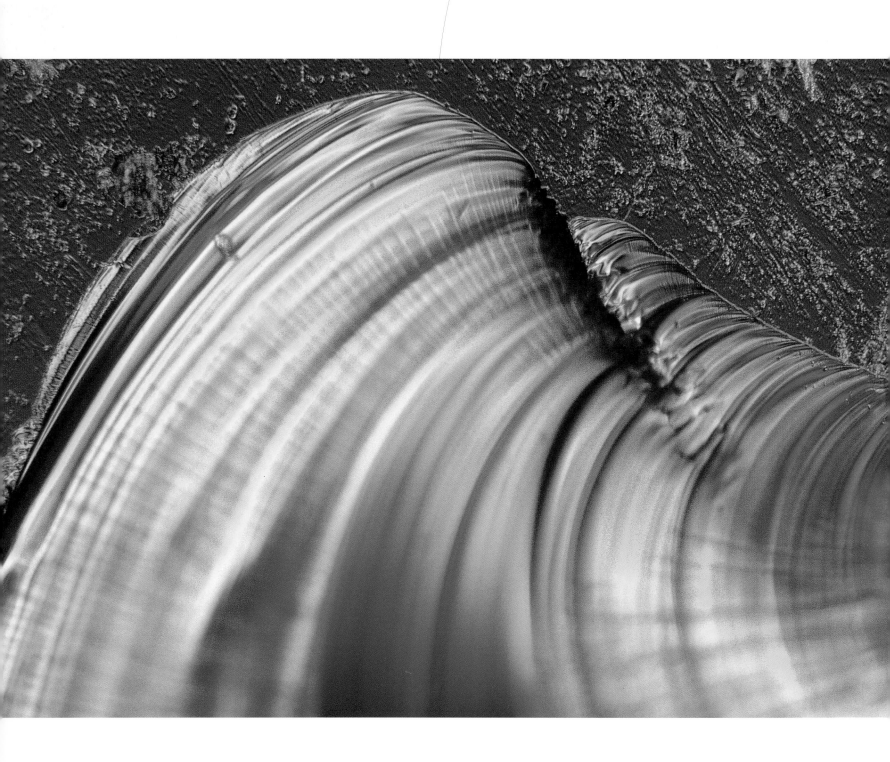

surface of broken glass

It is difficult to tear a handkerchief in half just by pulling on its ends. Notch its edge and it rips easily: the notch concentrates the tension in the threads at the tip of the tear and makes the fabric fail a few threads at a time. Glass fractures the same way: the forces at the tip of the growing crack pull apart the bonds between the atoms of which it is made.

Glass—a three-dimensional network of atoms bonded together—is hard and strong. It is also brittle: glass under tension splinters once a crack starts. When a wine glass hits the floor, it shatters; this apparently instantaneous explosion results from even faster local struggles between the glass and growing cracks. The cracks grow more rapidly than we can perceive, but they have episodic histories: spurts of growth, followed by pauses, recorded on their surfaces as "rings." The tension around a crack concentrates at its tip. As the tension increases, the glass first resists, then fails—a sequence too rapid for us to perceive. The crack shoots forward, ripping bonds apart in sequence—a zipper unzipping at nearly the speed of sound—until the tension is relieved and it pauses. The tension at the tip builds again, until the crack again jumps forward.

Here color helps to map the broken surface. The height of the fracture surface shows undulations that recount these spurts of fracture growth. These ripples are difficult to see, as the glass is transparent. This image uses a specialized microscopic technique to transcribe differences in the slope of the glass surface into colors.

To use solids, it is important to understand how they break. For carbon fiber in a fly rod, strength under tension is crucial; for concrete in the foundations of a bridge and for diamonds in a cutting tool, strength under compression and hardness are required. For automobile bumpers and armor, toughness—the ability to resist a tear or break once it has started—is most relevant.

"Sticking" has two parts: the liquid that is sticking and the surface being stuck to. Water is easy to wipe from the floor. Viscous liquids are difficult to remove: honey resists wiping; road tar refuses. The nature of the surface is important, too: nothing sticks to Teflon; everything sticks to an expensive suit.

An adhesive is a viscous liquid (so viscous it may be solid) that sticks well to the surfaces being glued. The most important factor in sticking is the surface. Surfaces that are wetted well by liquids — surfaces whose atoms wish to be covered by other matter — are easy to glue; ones whose surface atoms are indifferent to their exposure are more difficult.

When an adhesive fails — when the glue breaks — it can do so in many ways. The film of liquid adhesive can pull apart, like tearing chewing gum. The interfaces between the adhesive and the glued surfaces can fail. If the adhesive bond is very strong, the objects that are glued together may simply fracture internally.

As this adhesive failed, the very viscous adhesive liquid began to peel back from the surface, splitting into "fingers" that remained stuck to the surfaces, and the adhesive remaining in the fingers moved together laterally, perpendicular to the line of the retreating liquid.

failure in adhesion

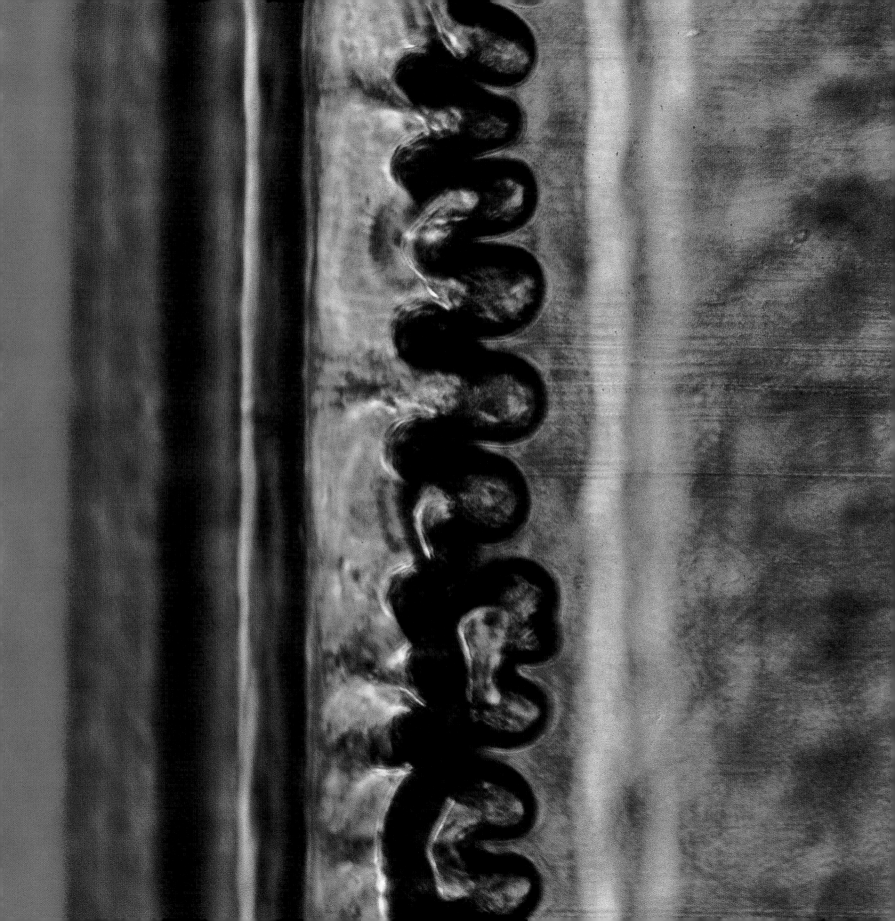

illusion

Our reality is illusion:
We don't know for sure
what's out there.

"Reality" is the composite report of sentries. Eyes see;
ears hear; nose smells; tongue tastes; hands touch. Each sends
complicated coded messages to the brain, but consciousness
receives only simplified summaries. Our reality is illusion:
We don't know for sure what's out there.

Sentries sometimes see things that don't exist, and there are
many ways to substitute a mirage for reality. Invisible
things may sometimes also be made visible—a shadow on
an X-ray film describing a tumor; the color of the fire's
embers telling their temperature.

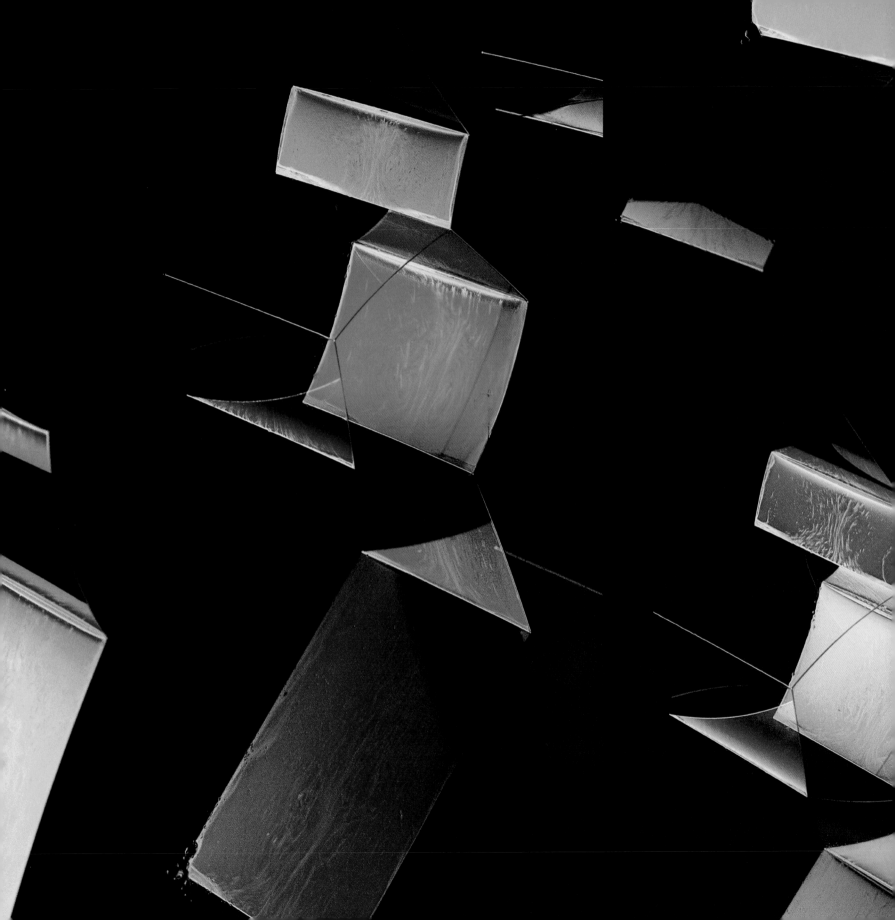

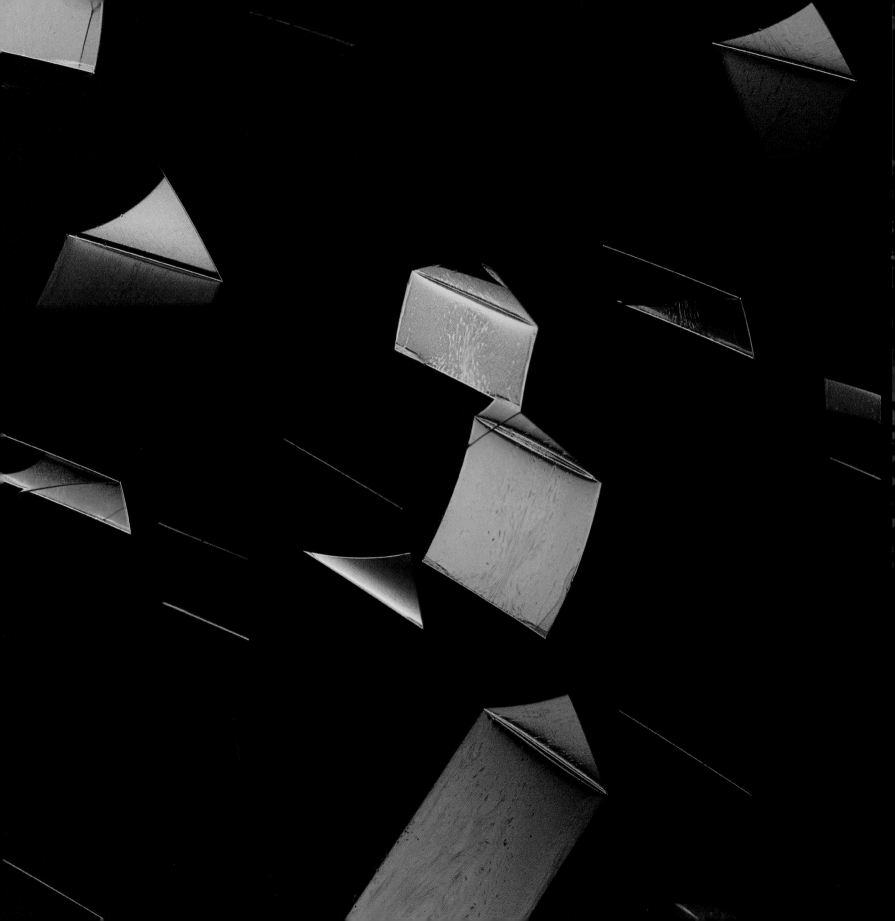

prismatic soap bubbles

PREVIOUS PAGES

Soap bubbles effortlessly answer the question, "For some volume in some space, what is the smallest surface area?" For the bubble blown by a child, the answer is simple: a sphere. For a congregation of bubbles confined between parallel glass plates a few centimeters apart, the answer is a prism.

The sides of these prisms are films only a few thousand molecules thick: the surfaces of the films are soap; their insides are water. Their shape is the one with the smallest area of surface: these films, like all liquids, try to minimize the fraction of their molecules that are exposed at a surface. Most light passes through most of the films without interaction. Occasionally, when the thickness of the film and the size of the light wave are similar, and when the light strikes at the correct angle, a single color reflects. Photons of that color rattle from side to side in the film; some come out on the same side they went in.

These prismatic bubbles were illuminated with white light—a mixture of all colors. Most of the films are invisible; a few reflect. The patterns show the structures of the films with startling precision. The colors define the depths of these microscopic seas, the swirls hint at their currents.

124

A butterfly is an improbable object under the best of circumstances— wings too large to be powered by its tiny body, too defenseless to survive in a hungry world. Its enormous wings are billboards advertising its existence, both to other butterflies and to predators. Each butterfly has a strategy for the use of this space: some paint their wings in camouflage; some color them brightly and advertise for companions; some warn of dire consequences to any eater (like the monarch butterfly, with its load of cardiotoxins extracted from the milkweed on which it feeds). The strategy of some is simply to mimic others' strategies.

When white light strikes the wings of the morpho butterfly from a certain angle, they appear to be a bright, shimmering blue. In fact, they are not blue at all: when viewed from other angles, they are dull browns and grays. The butterfly wastes no metabolic effort in synthesizing blue dye to paint its wings. Instead, its wings are mirrors that reflect only blue light: a collection of transparent microscopic tiles, formed at the thickness required to reflect the color blue selectively. The blue color is pure illusion: when sunlight—white light—strikes the wing, only blue is reflected.

wing of a morpho butterfly

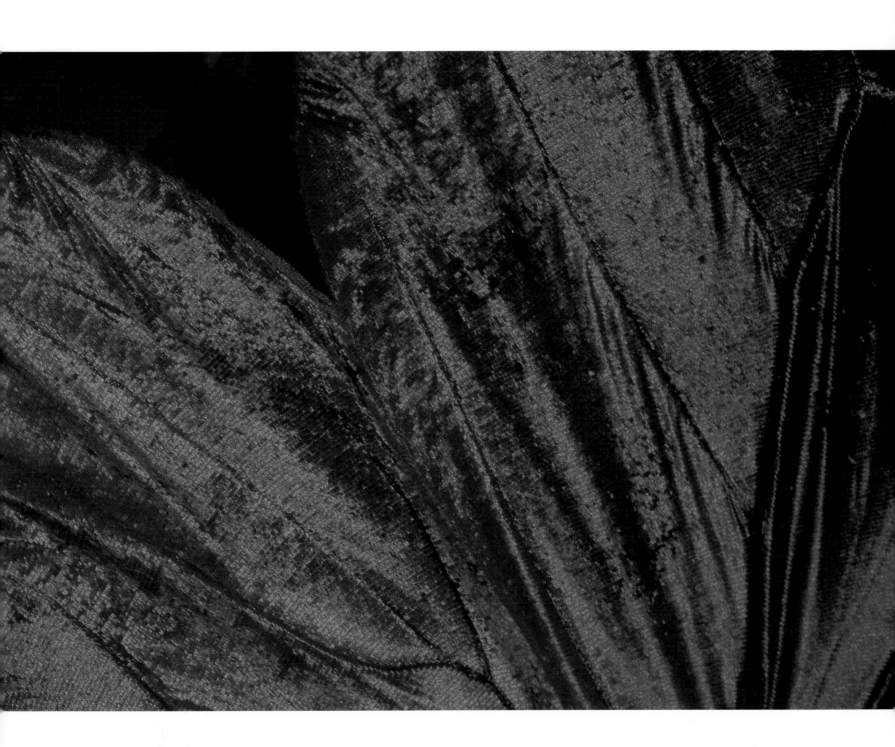

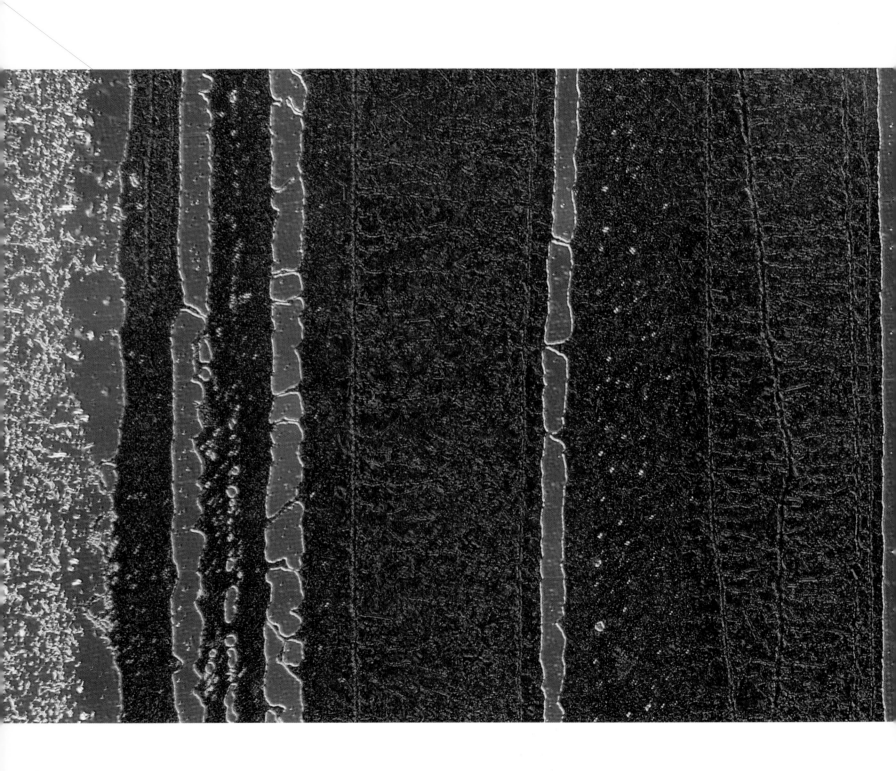

In opal, and in the wings of the morpho butterfly, nature has formed diffraction gratings that assemble themselves. We usually require ruling engines or lasers to draw the countless parallel lines that make up our diffraction gratings.

We can also form such gratings as the opal does, by crystallizing spheres in sheets, or as the morpho butterfly does, by coating a wing with plates of uniform size, but to do so we must first make particles of the correct size. One trick is to use an emulsion— a suspension of tiny droplets of one liquid in another—and to cause the liquid drops, once formed, to solidi- fy into solid spheres. The tiny drops of fat in milk are an emulsion, and the white color of milk comes from the reflection of light from these drops.

By forming plastic microspheres in the liquid droplets of an emulsion, it is possible to make them all one size. Allowing these uniformly sized plastic spheres to settle onto a surface in a thin film produces a regular array, like marbles on a plate. When the spheres are all approximately the wavelength of visible light, the regular thicknesses and spacings of the array make it a diffraction grating.

These two images are of the same trans- parent film of crystallized plastic microspheres illuminated with white light. The velvety green color of one is the result of diffraction. The brown and purple colors of the other image code the thickness of the ordered layers.

The ability of this film to appear green in reflected light when, in fact, it contains no colored dye, suggests new types of paint. Such paints would not lose their color by chipping or fading since there would be no dyed surface layer to fall off or bleach.

colors from
transparent spheres

dots on paper

Some patterns can only be seen at a distance: landing lights on the runway
at the airport; the spiral arms of a galaxy.
The face of your dearest companion
is unrecognizable from an inch away.

These dots are a small section of an
illustration in a magazine showing
the vials of fluorescent particles shown
in chapter 1. They are difficult to
interpret: the eye is distracted by the
extraneous details — the many dots —
that do not exist in the object itself.
When these dots are reduced in
size to the point that they cannot be
individually perceived by the eye,
the image emerges.

This blending of colors in a pointillist
printed image is a blessing. The
amount of detail available in a print —
the result of fragmenting a recognizable
image into several million separate
dots — would be overwhelming if our
eyes could see it distinctly. The amount
of detail in the original object itself
is even more extreme: if we could see its
individual molecules, we would drown
in useless information.

h o l o g r a m

"Seeing" is a kind of shadow play of images projected onto the screen of the retina. Light — high frequency electromagnetic ripples — strikes a coffee mug. The surface of the mug responds, reflecting some of the light waves. The lens of the eye focuses these reflected ripples onto the retina, where the excitation of cells in the retina is first interpreted locally, then actively discussed in a dialogue between the retina and the brain, and finally transmitted to the brain as a series of pulses in the optic nerve. Using this information, and taking clues from differences between the reports from the two eyes, the brain infers the mug's three-dimensional shape. Any process that builds the pattern of light that our eyes and brain interpret as "mug" will be a mug to us. We have no way of knowing if the patterns of light that fall on the retina are real or counterfeit without independent checks like smelling, feeling, and hearing.

With your eyes closed, a good stereo system is difficult to distinguish from a live orchestra: the sounds — the ripples of pressure in the air — produced by the two are indistinguishable. You can walk around in the sound from the stereo, and the pattern of vibrations is the same as in the symphony hall. Holography performs a similar trick for sight, recreating three dimensions from two. It uses interference among waves of light reflecting from the rippled surface of the hologram to build a three-dimensional pattern of light in space very similar to that coming from a mug. You can move your head and look around in this pattern, seeing the same variations in it that you would see with a real mug.

The major present uses of holograms are to provide security labels for credit cards and paper currency. In the future, holography may present three-dimensional information in books and on computer screens, and be a part of virtual reality.

131

When two boats run close and parallel, their wakes cross. Waves pile on one another, adding and subtracting in a complex pattern of interference. Where a wave in one wake adds to a wave from the second, the height of the combined wave is high; where the crest from one falls into the valley from the second, the two cancel and there is no wave.

The patterns in this image result from controlling the interference of waves of light. Light from a green laser was passed through a diffraction grating — a piece of transparent plastic whose surface was ribbed into many parallel, rectangular grooves. When the waves of this light encountered the surface of the grating, they broke into separate wavelets. As these wavelets rippled outward, they interfered with one another and the light diffracted to the sides.

The plastic used for the diffraction grating was a rubbery solid: the shape of its ribs — the diffraction grating — could be changed by pressing on them. These patterns are a composite of seven images, arranged horizontally. A square grating was adjusted so that no light was transmitted into the center — all was diffracted into images above and below. When a glass rod compressed a small area of the grating, a spot of transmitted light appeared in the center, and disappeared from the diffracted images. Moving the rod moved the position of the spot of light.

Designing systems in which the phase of light — the position of the wave maxima — is controlled in different regions is "wave-front engineering." Wave-front engineering is used to design diffraction elements for computer displays and optical communications, and for many other optical functions.

engineering light

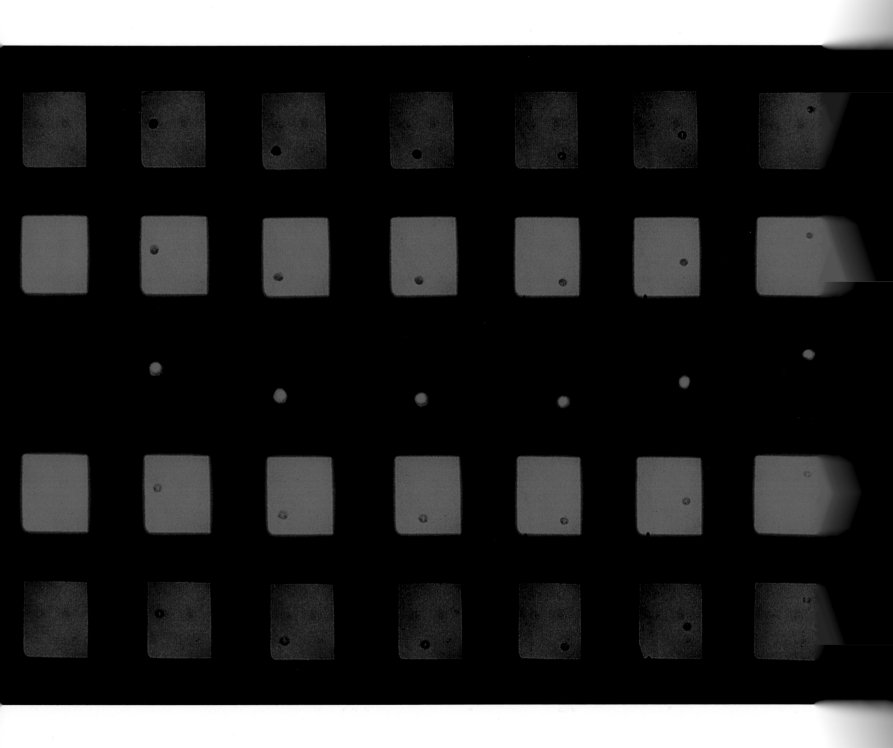

In late-night reruns of old Westerns,
the wagon wheels often turn backward.
The shutter of the camera blinks
at a fixed rate, each blink freezing the
position of the spokes. Depending
on the rate of the shutter and the speed
at which the wheel turns, the spokes
may appear to turn in reverse.

Differences between two periodic events
or structures are common. Two penny
whistles playing the same note will
warble: the frequencies of the note will
be slightly different for the two,
and the waves of sound from them will
periodically come into step and go
out of step. The patterns here—moiré
patterns—come from pieces of fabric.

moiré pattern ○

As the patterns of threads in each
piece come into and go out of coinci-
dence, subtle patterns of new lines
appear. These lines have a wavelength
much longer than that between the
threads.

Moiré patterns convert small differences
between two repeating patterns into
another pattern with a much longer
period of repetition. This third pattern
can be used to make very precise mea-
surements of distance and movement,
by allowing two periodic structures to
move relative to one another and
detecting the difference between the
two. Such systems measure dimensions
of ultraprecision parts and optical
components like lenses, and magnitudes
of small movements of structures,
when they are deformed mechanically.

shape of a molecule

To tell the shape of something, one must use a probe that is smaller than the object. Fingers work well to tell the shape of a dog, but not the shape of its fleas.

Molecules are very small: one to ten nanometers in diameter; 1 one-hundred-thousandth the size of the period at the end of this sentence. We have no "fingers" sensitive enough to let us feel the shapes of molecules, so we must try to see them. One way to "see" molecules—to infer their shape—is to shoot electrons at them and watch how the electrons scatter, since rapidly moving electrons behave much like light waves. The faster the electrons move, the shorter is their wavelength, and they can easily be brought to a speed high enough that their "size"—their wavelength—is sufficiently small to use for observing molecules. At this speed, unfortunately, they do great damage when they collide with the molecules in the crystals they are illuminating, so a course of experiments uses a series of crystals.

The molecule being examined is crystallized; when illuminated with electrons, it becomes a molecular crystal palace, with reflections everywhere. The pattern of these reflections reveals the shape of the identical molecules. In a crystal, molecules are organized in multiple, parallel planes. To electrons, these planes appear as semitransparent mirrors. Because the mirrors are in parallel stacks and the electrons are of only one "color"—one wavelength—they diffract: that is, they reflect only at certain angles. To find all the reflecting planes, the crystal is rotated in the beam of electrons, like the mirrored sphere at the disco.

The device used in this kind of experiment is an electron microscope. It is very like the cathode ray tube used for computer displays, but the very sharply focused electron beam is passed through a small crystal fixed in the tube, rather than being steered rapidly across the screen. When the beam is broken into multiple small beams by diffraction within the crystal, the phosphors of the display screen reveal the directions of these beams.

The result is a topographical map that shows the shape of a cluster of molecules, the pattern of diffracted spots locating the reflecting planes. An apple has a surface, a tangible edge, but drawing a sharp edge for a molecule is not possible. There are just atomic nuclei and the fog of electrons that cloaks them. This image suggests the shape of a protein important in setting the beat of the heart.

Crystallography using electrons, and much more importantly using X rays, has revolutionized our understanding of the shapes of biologically important molecules such as proteins. Crystallography using electrons requires only very small crystals, a major advantage, since growing crystals is often the most difficult part of a project. The information about structures obtained by either form of diffraction is very widely used in tracing biochemical pathways, in designing drugs, and in understanding disease.

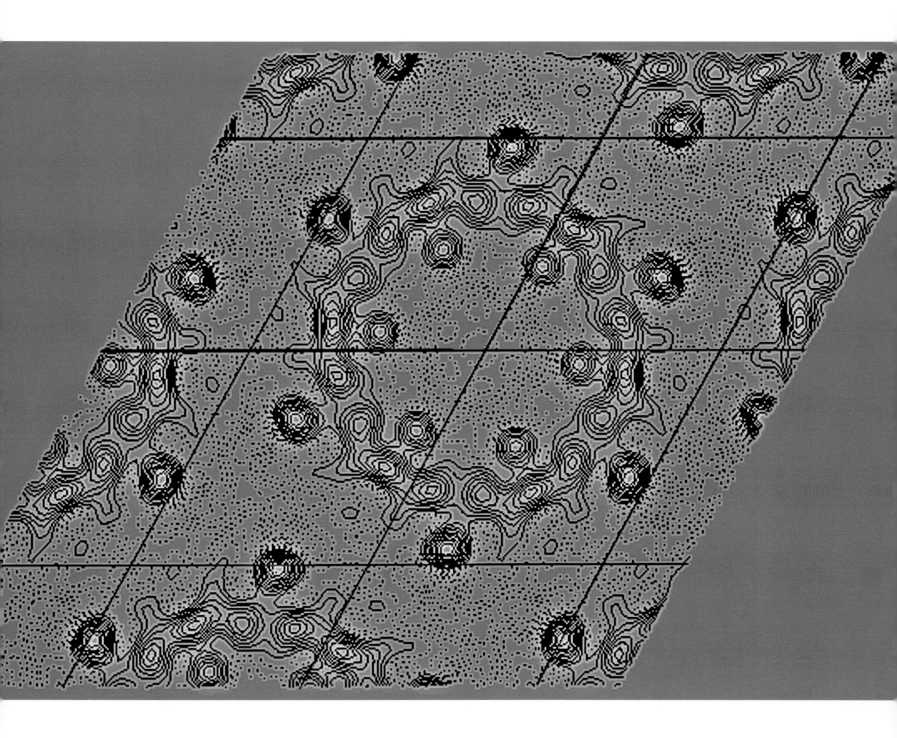

notes and readings

PHOTOGRAPHIC NOTES BY FELICE FRANKEL
TECHNICAL NOTES BY GEORGE WHITESIDES

Many of the italicized photographic notes that follow are accompanied by shorthand designations to indicate details of production. I used a Nikon F3 unless otherwise specified. The macroscopic images (Ma) were taken with either a 105 mm or a 55 mm macro lens, always on a tripod. The stereomicroscopic (SM) and microscopic (Mi) images were taken with camera adapters attached to each scope. Scanning electron microscopy (SEM) was usually performed with the help of a researcher.

I've specified which images were digitally cleaned (C) and digitally colored (DC). These new tools greatly freed me to give attention to issues such as light quality and composition without having to work around imperfections. As long as the photographer *indicates* the use of digital cleaning or coloring, and does not violate the integrity of the science, these tools are appropriate. I usually shot at $f22$ for the nonmicroscopic images and bracketed half stops up and down a full stop. Shutter speeds ranged from 1/8 second to 2 minutes. Film choices were Velvia 50 and Ektachrome 64 (tungsten).

My digital lab, 5000K Color Studios in Boston, scanned the images for enhancement on a Howtek drum scanner at 4000 dpi and recorded them onto 4 x 5 chromes with a LVT film recorder. Richard Kyle oversaw the digital cleaning, and I did some using Adobe Photoshop. All of my original film was processed by Zona Photographic Laboratories in Cambridge. Both labs take great pride in their work, and I'm glad I found them.

The optical microscopic images were usually taken with reflected light, unless otherwise indicated. Nomarski Differential Contrast (N) proved to be a valuable tool to emphasize surface features.

I give credit whenever possible to those who fabricated samples or helped with photography. The "Whitesides lab" refers to my coauthor's laboratory in the Department of Chemistry at Harvard University.

The technical notes and references by George Whitesides that follow each photographic note provide more information about details of the experiments and an introduction to the scientific literature.

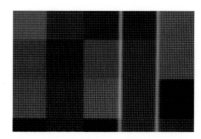

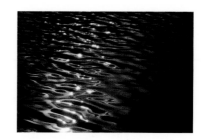

Oil Slick

*After hosing down my driveway on a gray
Sunday afternoon I searched for one of the more
interesting puddles and dropped a bit of oil
onto it. I waited half an hour until the diffraction
colors became interesting. With the camera and
105 mm lens on my tripod I shot perpendicularly
to the slick.*

Lynch, D. K., and W. Livingston, *Color and
Light in Nature,* Cambridge University Press,
Cambridge (1995).

Minneart, M.G., *Light and Color in the
Outdoors,* L. Seymor, trans. Springer Verlag,
New York (1993).

Moeller, K. D., *Optics,* University Science Books,
Mill Valley, Calif. (1988).

Ramme, G., "Colors on Soap Films—An
Interference Phenomenon," *Physics Teacher,*
28 (1990), 7, 479–80.

Smith, F. G., and J. H. Thomson, *Optics,* 2nd
ed., John Wiley & Sons, New York (1988).

Computer Monitor Screen

*I first digitally colored the black and white
portion of an image of my coauthor's tie (from his
home page). I then set up the tripod in front
of my computer screen and used a 2x extender on
my 105 mm macro and shot with daylight
film. I initially tried tungsten but found I preferred
daylight film's color. DC*

White, R., *How Computers Work,* Ziff Davis
Press, New York (1993), 115–19.

Reflections of Sunlight on Water

*I took this picture while photographing the garden
at Stourhead in England. I used my 105 mm
lens. The best bracket exposure emphasizing
the sun's reflections on the lake gave a blackness
to the water. Using color slide film for what is
basically a black and white image gives the subtle
colors I was looking for.*

Light is oscillatory electromagnetic radiation.
Low-frequency radiation—radio waves—
has very long wavelengths, and often interacts
with matter as a simple moving electrical
charge would. Very high-frequency radiation—
gamma and cosmic rays—behaves more
like particles: bullets blasting holes in matter
and leaving electrons scattered in their
wake. What we see and recognize as light is a
tiny part of the spectrum of frequencies (from
$4–8\times10^{14}$ sec^{-1}) with characteristics between
oscillating waves and energetic particles.
This narrow range is especially suited for use
by biological systems, especially eyes.
Light slightly higher in frequency than the
visible—ultraviolet light—damages DNA and
causes cancer. Light slightly lower in frequency—
infrared light—is completely absorbed by
water and does not reach the retina.

France, M. M. "Reflections on Rippling Water,"
American Mathematical Monthly, 100 (1993),
8, 743–48.

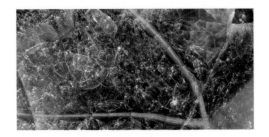

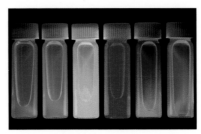

Veins of Opal

William Metropolis, the Curatorial Associate of the Mineralogical Museum at Harvard University, was kind enough to let me borrow a few large samples of opal. I set this particular specimen under daylight and captured the diffracting light with my 55 mm macro lens. Ma

Murray, C. A., and D. G. Grier, "Colloidal Crystals," *American Scientist*, 83 (1995), 238–45.

Ohara, P. C., et al., "Crystallization of Opals from Polydisperse Nanoparticles," *Physical Review Letters*, 75, (1995), 3466–69.

Suspensions of Small, Fluorescent Particles

Laying the vials horizontally to add air bubbles to the composition, I photographed the fluorescing samples with a 380 nm filter to absorb extraneous UV. I found Velvia to be the best film for this case. Certain wavelengths do not record well on various films—what I saw was not necessarily what I got on film. The samples are the work of Professors Moungi Bawendi and Klavs Jensen and graduate students Christopher Murray, Cherie Kagan, Bashir Daboussi, and Javier Rodriguez-Viego of MIT.

Cadmium selenide nanocrystals were prepared by precipitation and a monolayer of organic material was attached to the outside of the crystals with three useful effects: the organic layer acted as lubricant to prevent the particles from coagulating irreversibly in suspension; it protected their surfaces from reaction with oxygen and water; and it controlled the separation between particles when they crystallized.

The ability to change both the electronic structure of individual particles and the electronic coupling between them makes this system attractive for studying quantum dots.

Murray, C. B., C. R. Kagan, and M. G. Bawendi, "Self-Organization of CdSe Nanocrystallites into Three-Dimensional Quantum Dot Superlattices," *Science*, 270 (1995), 1335–37.

The Color Red

Here, I composed an edge of a ceramic platter (by artist David Hayes) and two red papers under my office skylight. I used my 55 mm macro lens. An ink mark on one of the papers was digitally removed. C

Chamberlin, G. J., *Colour, Its Measurement, Computation, and Application*, Heyden Publishing, London (1980).

Nassau, K., *The Physics and Chemistry of Color: The Fifteen Causes of Color*, John Wiley & Sons, New York (1983).

Schopenhauer, A., *On Vision and Colors*, Berg Publishers, Oxford (1994), originally published in 1816.

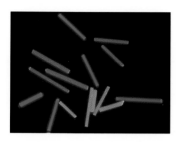

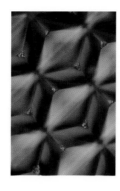

Tubular Gels

Professor Toyoichi Tanaka of the Department of Physics at MIT asked graduate student Changan Wang to create these gel shapes at my request. They were divided into three batches which were then placed in solutions of three different fluorescing dyes; fluorescein, rhodamine B, and ethyl coumarin. I composed the rods on a black tray and lit them with UV light. The gels that absorbed the fluorescein did not read well on tungsten film. I had them digitally tinted orange to approximate what the eye saw. Ma, DC

The gels are cross-linked polyacrylamide and were made by polymerization of acrylamide monomer in a glass tube, followed by extrusion of the rod of gel from the tube. The dyes are fluorescein (green), ethyl coumarin (blue), and rhodamine B (red).

Matsuo, E. S., and T. Tanaka, "Patterns in Shrinking Gels," *Nature* 358 (1992), 482–85.

Retroreflectors

William Bernett, formerly at 3M, supplied me with a sample of the material. I photographed it using a combination of reflected and transmitted light. Mi

This array of corner cubes is a 3M product and is part of a broad technology developed by this and other companies based on microreplication. This material is used for optical retroreflectors. Others are used to enhance the brightness of computer displays by directing more of the light toward the user, to distribute light in illumination systems, and to produce abrasives in which the shapes and orientations of the surfaces used in cutting are precisely controlled.

Feder, B. J., "Where Repetition Is Exciting," *New York Times*, 8 November 1995, C1 and C10.

Gagliardi, J. J., and M. V. Mucci, *Structured Coated Abrasives: A Whole New Approach*, 3M, St. Paul, Minn. (1995).

Optical Waveguides

Graduate student Xiao-Mei Zhao in the Whitesides lab gave me this sample, which she generated with Professor Mara Prentiss of the Harvard University Department of Physics. The colors are diffracted light from an auxilliary light source not attached to the microscope. Mi

An array of parallel waveguides (each having an approximately rectangular cross section, with dimensions 3 µm by 1 µm) was prepared on a Si/SiO$_2$ surface, using an optical polyurethane as the waveguiding material. The array was fabricated by microtransfer molding, using a polydimethylsiloxane mold.

Vassallo, C., "Optical Waveguide Concepts," *Optical Wave Sciences and Technology*, 1, Elsevier Publishing, Amsterdam (1991).

Zhao, X., et al., "Fabrication of Single-Mode Polymeric Waveguides Using Micromolding in Capillaries," *Advanced Materials*, 8 (1996), 420–424.

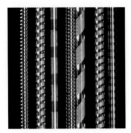

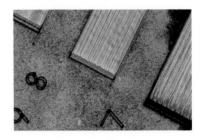

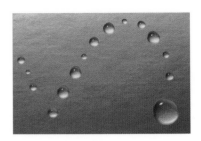

Metal Patterns on Glass Threads

Graduate student Rebecca Jackman and postdoctoral fellow John Rogers in the Whitesides lab imprinted these spiral and band patterns on hair-sized glass threads. I photographed them at different times with darkfield microscopy and had the images digitally combined. Mi, C

These patterned fibers were produced by a several-step process. The glass fiber was first coated with a thin film of gold by electron beam evaporation. This gold film was printed with a spiral or banded pattern of octadec-anethiolate by microcontact printing. The unprotected gold was removed by etching, to leave the patterns shown in gold. When it was important to have the wires carry significant current, the gold was used as an electrode for electrodeposition of silver.

Rogers, J. A., et al., "Using Microcontact Printing to Generate Amplitude Photomasks on the Surfaces of Optical Fibers: A Method for Producing In-Fiber Grating," *Applied Physics Letters,* 70 (1), 1997, 7–9.

Wilbur, J. L., et al., "Microcontact Printing of Self-Assembled Monolayers: A New Technique for Microfabrication," *Advanced Materials,* 6 (1994), 600–604.

Silicon, Etched by Light

Theodore Bloomstein's work for his doctoral thesis in the Department of Electrical Engineering and Computer Science at MIT involved laser etching silicon surfaces. I used his reference numbers as a compositional element. Mi, N

With this technology, three-dimensional structures can be rapidly machined in silicon to micrometer tolerances. This work benefits the emerging field of microelectromechanical systems (MEMS) by extending milling techniques to new size regimes. MEMS merges electronic and mechanical components to produce sensors and actuators such as pressure transducers, valves, and pumps. Current techniques for fabricating these mechanical components rely on lithographic techniques that limit shapes to extrusions of two-dimensional patterns. Laser processing offers a means to produce mechanical components that are inherently more three-dimensional.

Bloomstein, T. M., and D. J. Erlich, "Laser Deposition and Etching of Three-Dimensional Microstructures," *TRANSDUCERS '91, 1991 International Conference on Solid-State Sensors and Actuators, Digest of Technical Papers,* 507–11.

Bloomstein, T. M., and D. J. Erlich, "Stereo Laser Micromachining of Silicon," *Applied Physics Letters,* 61 (1992), 708.

Drops of Water

Placing individual drops with the tip of a steak knife on a gold fiftieth anniversary card in various pattern formations, I found the simplest pattern was the most interesting. Ma, C

These drops are water drops on a hydrophobic plastic surface. The shadowing of the drops shows internal lensing. The surface of the drop focuses the light on the surface opposite to that on which the light falls. This lensing can have practical consequences: drops of water on the surface of a car, in the bright sun, can focus the sunlight on the paint and cause local damage.

Kim, E., and G. M. Whitesides, "The Use of Minimal Free Energy and Self-Assembly to Form Shapes," *Chemistry of Materials,* 7 (1995), 252–54.

Whitesides, G. M., and C. B. Gorman, "Self-Assembled Monolayers: Models for Organic Surface Chemistry," *Handbook of Surface Imaging and Visualization,* A. T. Hubbard, ed., CRC Press, Boca Raton (1995), 713–33.

142

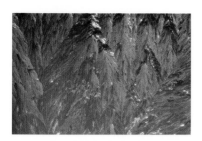

Ice Crystals

I shot through my windowpane into the winter sunset. I used daylight film although the temperature (K) was closer to tungsten. Ma

These quasi-two-dimensional crystals of ice are growing in kinetically controlled patterns and are strongly influenced by mass transport (and possibly heat transport). The crystal masses appear to be close to fractal in their patterns of growth.

Davey, R., and D. Stanley, "All About Ice," *New Scientist,* 140 (1993), 33–37.

Harrison, A., *Fractals in Chemistry,* Oxford Science Publishing, Oxford (1995).

Walker, J., "Icicles Ensheathe a Number of Puzzles: Just How Does the Water Freeze?" *Scientific American,* 258 (1988), 5, 114–17.

Stamp for Microprinting

I used tungsten lamps to produce the diffraction colors for postdoctoral fellow James Wilbur's and Rebecca Jackman's sample from the Whitesides lab. A similar image appeared on the cover of Science, *August 4, 1995. Ma*

An elastomeric stamp made of transparent polydimethylsiloxane (PDMS) is formed by casting the polymer against a master structure that has a pattern of features in bas-relief on its surface. The stamp is "inked" with a compound that forms a self-assembled monolayer on the surface being patterned: a typical combination is a PDMS stamp, an alkanethiol "ink," and a flat gold surface. The inked stamp comes into contact with the gold surface; an image complementary to the pattern on the surface of the stamp forms. The resolution of this pattern is remarkable: the roughness of the edges of the pattern is less than 50 nm, even when the process is carried out in the open laboratory.

The colors from the front side are those of diffraction of light propagating in air; those from the back side are from diffraction of light propagating in PDMS.

Kumar, A., et al., "Patterned SAMs and Meso-Scale Phenomena," *Accounts of Chemical Research,* 28 (1995), 219–26.

Xia, Y., et al., "Microcontact Printing of Alkanethiols on Silver and Its Application in Microfabrication," *Journal of the Electrochemical Society,* 146 (1996), 1070–79.

Small Parallel Rods

Enoch Kim, a graduate student in the Whitesides lab, produced this sample, and I shot it using darkfield. Mi, C

A polydimethylsiloxane (PDMS) stamp having a surface relief structure of 20 μm-square grooves was placed in contact with the surface of a glass plate. A drop of liquid prepolymer (an optical polyurethane) placed at the open end of the capillary network filled it by capillarity. A number of polymers could be used, the most important criterion being the lowest possible viscosity of the prepolymer. Polymers with viscosity similar to that of maple syrup took several hours to move a few millimeters along the capillaries. The liquid prepolymer was solidified by irradiation with ultraviolet light through the PDMS stamp. All rods begin at a common line perpendicular to their long axis, and the variation in their length is a few hundred μm over approximately 1 cm.

143

Kim, E., Y. Xia, and G. M. Whitesides, "Micromolding in Capillaries: Applications in Materials Science," *Journal of the American Chemical Society,* 118 (1996), 24, 5722–31.

Xia, Y., E. Kim, and G. M. Whitesides, "Micromolding of Polymers in Capillaries: Applications in Microfabrication," *Chemistry of Materials,* 8 (1996), 1558–67.

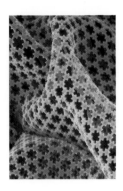

Inks Bleeding on Fabric

Plastic Microstructures

Molded Plastic Microfabric

This is a detail of my favorite handmade scarf. The artist had placed the inks on the fabric anticipating how far they would bleed. I shot it under diffused daylight with the 55 mm lens.

Capillary wicking is almost universal on contact of a liquid with a porous solid, so long as the contact angle of the liquid on the solid is less than 90°. The liquid-vapor interfacial free energy may or may not be important in capillary wicking: if the capillaries are completely closed, wicking may result in very little change in liquid-vapor surface area. In wicking of liquid into this porous fabric, there is a significant increase in the liquid-vapor area, and the surface tension of the liquid is important.

Adamson, A. W., *The Physical Chemistry of Surfaces,* John Wiley & Sons, New York (1990).

Isrealachvili, J. N., *Intermolecular and Surface Forces, with Applications to Colloidal and Biological Systems,* Academic Press, New York (1985).

I used darkfield on this sample generated by Andrew Black, a graduate student in the Whitesides lab. Mi

These figures are thin layers of plastic that self-assembled on the surface of silver-coated glass as a result of differential wetting. The wettability of the surface of the silver was modified with a self-assembled monolayer patterned by microcontact printing. The pattern was stamped with a hydrophilic acid, washed, and immersed in a liquid polyurethane prepolymer that selectively wetted the hydrophilic regions of the surface and retreated from the other hydrophobic regions. The polymer assumed a shape that minimized its free energy and was cured by exposure to UV light.

Abbott, N. L., et al., "Using Finite Element Analysis to Calculate the Shapes of Geometrically Confined Drops of Liquid on Patterned, Self-Assembled Monolayers: A New Method to Estimate Excess Interfacial Free Energies," *Journal of the American Chemical Society,* 116 (1994), 290–94.

Biebuyck, H. A., and G. M. Whitesides, "Organization of Organic Liquids on Patterned Self-Assembled Monolayers of Alkanethiolates on Gold," *Langmuir,* 10 (1994), 2790–93.

Graduate student Younan Xia in the Whitesides lab took the original SEM, and postdoctoral fellow Nikolaos Wilmore helped me with the digital coloring using Adobe Photoshop. The colored image appeared on the cover of Nature, *August 17, 1995. SEM, DC*

A transparent PDMS stamp was prepared by casting a liquid prepolymer across a relief structure of photoresist; the pattern was introduced by conventional photolithography. The PDMS stamp, on contact with a flat piece of glass, formed a network of channels with minimum channel diameter of approximately 1 μm. A liquid epoxy prepolymer was brought into contact with this network and filled it by capillarity. Thermal or photochemical crosslinking of the prepolymer (using light transmitted through the PDMS) gave a solid network. Peeling away the PDMS stamp left the network of polymer on the glass, which was then dissolved to release the plastic fabric.

Kim, E., Y. Xia, and G. M. Whitesides, "Polymer Microstructures Formed by Moulding in Capillaries," *Nature,* 376 (1995), 581–84.

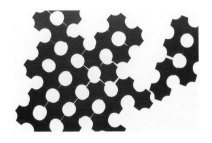

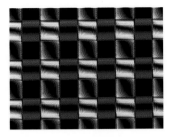

Self-Assembled Structure

*It was remarkable how quickly the structures
assembled as soon as I placed them at the interface
of perfluorodecalin and water. Graduate student
Ned Bowden in the Whitesides lab generated
the individual shapes. I photographed them
in a round glass laboratory dish over white paper
under daylight with a 105 mm lens. Ma, C*

Small, cross-shaped pieces of PDMS were
prepared in several steps. A long rod of PDMS
with this cross section was cast from
a mold. The flat sides of the rod were covered
with Scotch tape, and the exposed faces of
PDMS were oxidized in a plasma generator until
they became hydrophilic. The tape was
removed from the PDMS, and the individual
pieces of PDMS were cut from the rod
and floated between perfluorodecalin (chosen
for high hydrophobicity and density) and water.
The hydrophilic surfaces of the polymer were
wetted by water; the perfluorodecalin wet the
hydrophobic surfaces, creating menisci. The
elimination of these menisci caused the assem-
bly.

Kralchevsky, P. A., and K. Nagayama, "Capillary
Forces between Colloidal Particles," *Langmuir,*
10 (1994), 23.

Whitesides, G. M., J. P. Mathias, and C. T. Seto,
"Molecular Self-Assembly and Nanochemistry:
A Chemical Strategy for the Synthesis of
Nanostructures," *Science,* 254 (1991), 1312–19.

Coated Silver Wires

*Paul Nealey, a postdoctoral fellow in the Whitesides
lab, produced the sample. The crisscrossing of
the polymer created interference patterns exaggerated
with Nomarski. Mi, N, C*

A substrate was prepared by evaporation of
a 50-nm thick film of silver onto a silicon wafer.
A pattern of 50-μm-wide lines was printed
onto the surface using microcontact printing.
The surface not covered with this initial
self-assembled monolayer was covered by a
resist by dipping the initially patterned
surface into an appropriate solution. Dipping
the patterned surface into liquid prepolymer
(an optical adhesive) resulted in covering
the hydrophilic parts of the pattern with liquid
prepolymer and leaving the hydrophobic
parts bare.

The polymer was cured by exposure to UV
light, and the resist and the exposed silver
were removed. Repeating the process a second
time, with lines stamped perpendicular to the
first set, generated the structure we see here.

Biebuyck, H. A., and G. M. Whitesides, "Self-
Organization of Organic Liquids on Patterned
Self-Assembled Monolayers of Alkanethiolates
on Gold," *Langmuir,* 10 (1994), 1790–93.

Lopez, G. P., et al., "Imaging of Features on
Surfaces by Condensation Figures," *Science,*
260 (1993), 647–49.

Multiple Experiments

*Xiau Dong Xiang, a Research Fellow at the
Lawrence Berkeley Laboratories, University of
California at Berkeley, supplied me with
the sample. The image was taken with daylight.
In order to get interesting colors, I had to shoot
at an angle. I later digitally corrected the distorted
perspective. Ma, C*

145

A series of combinations of elements associated
with high-temperature superconductivity were
sputtered onto a surface in different sequences
forming "libraries" of 16 to 128 separate experi-
ments. After deposition, the entire array was
heated to 840˚C, and then the electrical resis-
tance of the individual spots was measured
at temperatures down to 4.2˚K to detect
electrically superconducting materials.
Although no compositions were discovered
that were superconducting at temperatures
higher than those already known, the best mem-
bers of the library duplicated existing high-
temperature superconducting materials.
This strategy is called combinatorial synthesis
for its ability to try many possible combina-
tions efficiently and easily, and for the analyti-
cal technique used to design the experiments.

Xiang, X.-D., et al., "A Combinational Approach
to Materials Discovery," *Science,* 268 (1995),
1738–40.

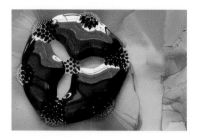

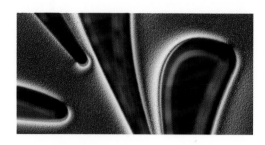

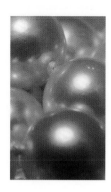

146

Ferrofluid

I dropped a few ml of the dark brown liquid on a glass plate and placed that on yellow paper resting on six circular magnets measuring about 1 cm in diameter each. The magnets created the pattern you see. Ma, C

A ferrofluid is a stable superparamagnetic suspension of a magnetite colloid with sizes of approximately 10 nm—smaller than the domains required for stable ferromagnetism.

Raj, K., and R. Moskowitz, "Commercial Applications of Ferrofluids," *Journal of Magnetism and Magnetic Materials*, 85 (1990) 233–45.

Rosensweig, R., *Ferrohydrodynamics*, Cambridge University Press, New York (1995).

Small Machines

I photographed the blades of a microrotor fabricated by Chunang-Chia Lin from Professors Stephen Senturia's and Martin Schmidt's labs in the Department of Electrical Engineering and Computer Sciences, MIT. Choosing which plane to keep in focus is always a question in microscopic photography. Mi, N

Gabriel, K. J., "Engineering Microscopic Machines," *Scientific American*, 273 (1995), 3, 150–53.

Jardin, A. P., et al., eds., *Smart Materials Fabrication and Materials for Microelectro-mechanical Systems*, Materials Research Society Proceedings, 276 (1992).

Rogers, C. A., "Intelligent Materials," *Scientific American*, 273 (1995), 3, 154–61.

Pearls

I put a string of pearls under diffused daylight and shot with a 105 mm lens. Ma

Sarikaya, M. and I. Aksay, eds., *Biomimetics: Design and Processing of Materials*, American Institute of Physics, Woodbury, N.Y. (1995), 35–90.

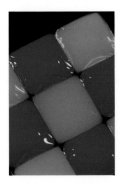

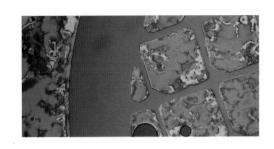

Square Drops of Water

Nicholas Abbott, then a postdoctoral fellow in the Whitesides lab and now a professor at the University of California at Davis, said we could emphasize the shape of the drops by adding fluorescing dyes to the water without changing the integrity of the science. I used UV as a light source, and the image appeared on the cover of Science, September 4, 1992. Ma

The surface on which the drops rest is a hydrophilic, self-assembled monolayer supported on a thin gold film. Micromachining of 1-µm lines into this surface in a square grid exposed bare gold; these lines of bare gold were covered with a hydrophobic self-assembled monolayer. Drops of water containing dyes were then introduced into the square hydrophilic areas. The drops did not mix between squares, despite the small separation between their edges.

Abbott, N. L., J. P. Folkers, and G. M. Whitesides, "Manipulation of the Wettability of Surfaces on the 0.1–1-Micrometer Scale Through Micromachining and Molecular Self-Assembly," *Science*, 257 (1992), 1380–82.

Crystals of Small Particles

I had to coax graduate students Christopher Murray and Cherie Kagan in Professor Moungi Bawendi's lab at MIT to allow me to see how these nanoclusters appeared under an optical microscope. The researchers were more interested in SEM. I used darkfield microscopy. Mi

This image is a darkfield optical micrograph of ordered crystals of CdSe, the surface stabilized by a thin adsorbed film of an n-alkanethiolate. They are back-illuminated with polarized light, and the picture was taken with crossed polarizers. The crystals were produced by depositing a drop of a suspension of the colloid in a solution on a fused silica slide and then allowing the solvent to evaporate under reduced pressure. The yellow color is from depolarized luminescence; the green is from birefringence; the red is believed to correlate with grain boundaries in the crystal.

Murray, C. B., C. R. Kagan, and M. G. Mawendi, "Self-Organization of CdSe Nanocrystallites into Three-Dimensional Quantum Dot Superlattices," *Science*, 270 (1995), 1335–37.

Ohara, P. C., et al., "Crystallization of Opals from Polydisperse Nanoparticles," *Physical Review Letters*, 75 (1995), 3466–69.

Liquid Crystal Film

The sample was mailed from Nicholas Abbott's lab at the University of California at Davis and traveled well. The grids alone were not enough to make the image interesting, so I included the non-patterned area as a compositional element. Mi, N

Both surfaces of the cell containing the liquid crystal (LC) were self-assembled monolayers (SAMs) supported on semitransparent gold. The pattern in the texture of the liquid crystal was caused by a patterned SAM on one surface of the cell. The disordered regions were caused by competing boundary conditions (the SAM on one surface causing the LC to align parallel to the surface, the SAM on the other surface causing the LC to align normal to the surface). The uniform brown regions have matching surfaces (SAMs on both surfaces cause the LC to align normal to the surface).

Collins, P. J., *Liquid Crystals: Nature's Delicate Phase of Matter*, Princeton University Press, Princeton (1990).

Drawhorn, R. A., and N. L. Abbott, "Anchoring of Nematic Liquid Crystals on Self-Assembled Monolayers Formed from Alkanethiols on Semitransparent Films of Gold," *Journal of Physical Chemistry*, 99 (1995), 45, 16511–15.

147

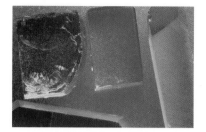

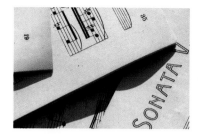

Man-Made Crystal

Sheet Music

Player Piano Rolls

Robert Birgeneau, Dean of the School of Science at MIT, works with artificially produced crystals. These were placed on a glass plate which I thought added nice color to the image. The crystals were photographed under daylight with a 105 mm lens. Ma

This old piece of music, printed in Hungary, was shot outside with a 105 mm lens at around 2:00 in the afternoon. At this time of day, shadows are not so overwhelming that they become more than just an additional compositional element. Ma

I unrolled one of the four I bought in an antique store on a glass table and left the hint of the tungsten light's reflection peeking through one of the holes. I used a 55 mm lens. Ma, C

Gill, D., ed., *The Book of the Piano,* Cornell University Press, Ithaca (1981).

Wier, A. E., *The Piano, Its History, Makers, Players, and Music,* Longmans, Green and Co., London (1940).

These crystals are calcium fluoride and manganese fluoride, materials used in experiments with lasers operating in the UV. The crystals were grown by top-seeding, in which a small seed crystal is brought into contact with a flux heated to a temperature near the optimal growth temperature. As the heat is lost by radiation or conduction, the flux cools and the seed crystal grows. Heat can be delivered either electrically or by using an infrared laser.

Klamkin, C., *Old Sheet Music: A Pictorial History,* Hawthorn Books, New York (1975).

Krummel, D. W., *The Literature of Music Bibliography: An Account of the Writings on the History of Music Printing and Publishing,* Fallen Leaf Press, Berkeley, Calif. (1992).

Gilman, J. J., ed., *The Art and Science of Growing Crystals,* John Wiley & Sons, New York (1963).

Yeh, P., *Crystals,* John Wiley & Sons, New York (1988).

148

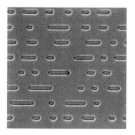

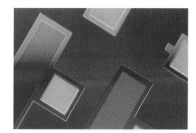

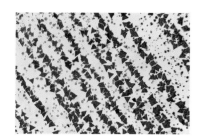

Compact Disc

Postdoctoral fellow Albert Folch in the Department of Electrical Engineering and Computer Science at MIT helped me create this scanning electron micrograph at the Microsystems Technology Laboratories at MIT. SEM, DC

Baert, L., L. Theunissen, and G. Vergult, eds., *Digital Audio & CD Technology*, 2nd ed., Newnes, Oxford (1992).

Diamond Electron Emitters

Staff scientist Michael Geis at the Lincoln Labs at MIT gave me one of his samples. If you look carefully you can see the non-uniformity of the background emphasized with Nomarski. Mi, N, C

New methods for preparing diamonds are a recent development. For years, artificial diamonds have been grown under extremes of temperature and pressure. They can now be grown at atmospheric pressure and relatively low temperature from the vapor phase by chemical vapor deposition, which generates molecular fragments containing carbon atoms and hydrogen atoms. The carbon deposits on a surface as a mixture of amorphous carbon and high-carbon polymers, graphite, and small quantities of diamond. The hydrogen atoms react with all of these, reconverting them to volatile carbon. The reaction is slowest with diamond, which remains when the others are burned away. The cold-cathode emitters shown in this image have an array of holes filled with diamond paste and baked under hydrogen at 1080°C. Electron emission occurred at very low electric field (0–1 V/μm).

Geis, M. W., and J. C. Angus, "Diamond Film Semiconductors," *Scientific American*, 267 (1992), 84–89.

Nucleation of Crystal Growth

I asked Cherie Kagan at MIT if I could photograph the assembled nanoclusters she generated in a vial. I was having difficulty shooting through the glass. One day when the vial fell to the floor and cracked, I removed part of the glass, exposing the material. Mi, C

The growth of these crystals of cadmium selenide was accidental: nucleation occurred spontaneously along accidental scratches. The formation of crystals along these straight lines demonstrates a strategy commonly used to induce crystallization: the walls of a glass flask containing a solution are scratched or rubbed with a glass rod, producing scratches in the surface of the glass and generating fine particles of glass. Both act as nucleation centers for crystal growth. These crystals formed along lines radiating from the center, a pattern characteristic of cracks formed in the surface of the glass during its manufacture.

Murray, C. B., C. R. Kagan, and M. G. Mawendi, "Self-Organization of CdSe Nanocrystallites into Three-Dimensional Quantum Dot Superlattices," *Science*, 270 (1995), 1335–37.

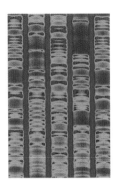

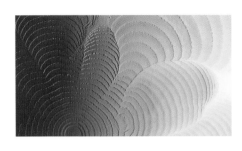

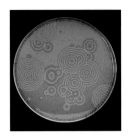

Analysis of DNA

Migrating Bacteria

Oscillating Chemical Reaction

I cut a 4 x 5 piece from Qiang Zhou's original X-ray film from Professor Philip Sharp's lab in the Department of Biology at MIT. The film recorded DNA sequences. I scanned it on a Leaf 45, and colored it slightly with Photoshop. DC

The light for this shot was unusual: to read the contours I had to combine front lighting with irregular back lighting. Using a magnifying mirror that reflected an irregular background, I placed the petri dish on an angle. Professor James Shapiro in the Department of Biochemistry and Molecular Biology at the University of Chicago was kind enough to bring me samples from Chicago. Ma, C

Undergraduate student Matthew Eager helped set up the reaction in Professor Anatol Zhabotinsky's lab in the Department of Chemistry at Brandeis University. We placed the petri dish containing the reactants on a light table and surrounded it with black cloth. I took an exposure every 15 seconds and was amazed at the regularity of the oscillations. These eight images are an edited representation of the series I shot.

Tat Stimulatory Factor 1 (Tat-SF1) is a protein produced by a human cDNA clone that encodes this cellular cofactor for human immunodeficiency virus-1 (HIV-1 Tat). The Tat protein stimulates transcription from the HIV-1 long terminal repeat with the help of several cellular proteins, including Tat-SF1. Tat is absolutely essential for replication of HIV-1. This DNA sequencing gel shows the DNA sequence of the NH_2-terminal portion of the Tat-SF1 gene.

Bacteria are favored organisms for the study of how a stimulus sensed by an organism and converted into a signal inside the cell results in an observable change in behavior. The responses of bacteria to simple chemical signals are reasonably well understood, The behavior of collections of bacteria is much more complicated. The beautiful regularity and complexity of this pattern of *Proteus* colonies was unexpected. One key to the formation of the visible terraces is the density of growth: when the population of bacteria reaches a certain level, it differentiates a limited subpopulation of swarmer cells that move out and colonize a new region.

These images are of the Belousov-Zhabotinsky (BZ) reaction. The reactants are malonic acid and bromate ion in acid solution. The colored bands are due to an indicator dye that indicates the oxidation potential of the solution. The overall process leading to the oscillating bands requires at least four coupled chemical reactions. It is possible to simulate the basic patterns generated in these systems by computer. An accurate description of the reaction requires integrating a set of twenty-five or thirty reactions. The dots in the image are an artifact: they are bubbles of gas that have formed in the reaction medium.

Gonick, L., and M. Wheelis, *The Cartoon Guide to Genetics*, Harper Collins, New York (1991).

Sharp, P. A., and R. A. Marciniak, "HIV TAR: An RNA Enhancer?" *Cell*, 59 (1989), 229–30.

Watson, J. D., et al., *Recombinant DNA*, 2nd ed., Scientific American Books, W. H. Freeman and Co., New York (1992).

Zhou, Q., and P. A. Sharp, "Novel Mechanism and Factor for Regulation by HIV-1 Tat," *EMBO Journal*, 14 (1995), 321–28.

Shapiro, J. A., "Bacteria as Multicellular Organisms," *Scientific American*, 256 (1988), 82–9.

Shapiro, J. A., and D. Trubatch, "Sequential Events in Bacterial Colony Morphogenesis," *Physica*, D 49 (1991), 214–23.

Epstein, I. R., "Patterns in Time and Space," *Chemistry and Engineering News*, 30 March (1987), 24–27.

Fife, P. C., "Understanding the Patterns in the BZ Reaction," *Journal of Statistical Physics*, 39 (1985), 687–703.

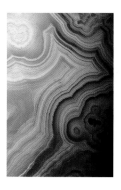

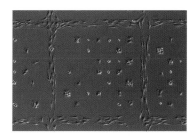

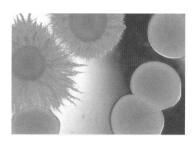

Agate

Using auxilliary tungsten lighting and the stereomicroscope, I photographed a sample of agate from my colleague Elizabeth Connors' mineral collection. SM

Heaney, P. J., and A. M. Davis, "Observation and Origin of Self-Organized Textures in Agates," *Science,* 269 (1995), 5230, 1562–65.

Merino, E., "Genesis of Agates in Flood Basalts: Twisting of Chalcedony Fibers and Trace-Element Geochemistry," *American Journal of Science,* 295 (1995), 9, 1156–76.

Wang, Y., and E. Merino, "Origin of Fibrosity and Banding in Agates from Flood Basalts," *American Journal of Science,* 295 (1995), 1, 49–77.

Mammalian Cells on a Patterned Surface

Christopher Chen, a graduate student working with Professor Donald Ingber at Children's Hospital in Boston, gave me these samples. Nomarski emphasizes the cells' outlines. Mi, N

The surface was patterned by microcontact printing two types of self-assembled monolayers on gold. The surfaces to which the cells were to attach were covered with a monolayer of organic molecules that terminated in methyl ($-CH_3$) groups. This surface adsorbed proteins that permit cellular attachment— fibronectin, laminin. The remaining surface was covered with another molecule terminating in oligo(ethylene glycol) groups ($-CH_2CH_2O)_nOH$. Neither proteins nor cells attach to these surfaces. The cells were bovine capillary endo-thelial cells. They were plated in serum-free media, cultured overnight, and fixed in 4% formaldehyde in phosphate-buffered saline solution.

Mrksich, M., and G. M. Whitesides, "Patterning Self-Assembled Monolayers Using Microcontact Printing: A New Technology for Biosensors?" *TIBTECH,* 13 (1995), 228–35.

Colonies of Yeast

I asked Julie Kohler, research fellow in Professor Gerald Fink's lab at the Whitehead Institute, to grow both types of colonies on one petri dish. Ordinarily, the procedure is to grow them separately. This particular stereomicroscope gave me more control over the light source than newer versions. I prefer this older type of microscope because of that ability. The light in this case was reflected off a mirror. SM

151

Wild-type *Candida albicans* was modified by homozygous disruption of the CPH1 gene. This gene is homologous to a gene (Ste12p) in *Saccharomyces cerevisiae* (baker's yeast) known to be involved in the yeast pheromone response pathway and important in mating of this yeast. This image is of wild-type and genetically modified strains of *C. albicans* using conditions that cause expression of the fila-mentous morphology; only the wild-type yeast is able to respond to these conditions.

Liu, H., J. Kohler, and G. R. Fink, "Suppression of Hyphal Formation in *Candida albicans* by Mutation of a STE 12 Homolog," *Science,* 266 (1994), 1723–26.

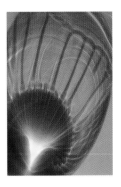

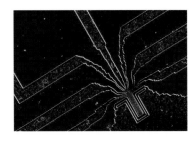

Tears of Wine

Microelectrodes

Shakespeare's Signature

After a series of attempts at directly photographing the wine, I discovered that the shadowgram gave the best portrayal of the Marangoni effect.

The origin of surface tension is the tendency of molecules to surround themselves with other molecules. Molecules at a liquid-vapor or solid-vapor interface do not enjoy the energetic stabilization that would come from being completely surrounded by others.

The Marangoni effect is the effect responsible for "tears" or "legs" of wine. The surface tension of a solution of ethanol in water is substantially lower than that of pure water. The water-ethanol mixture coats the surface of the wine glass when it is swirled, and the large surface area of the thin liquid film allows rapid volatilization of the ethanol from the uppermost portions of the film and an accompanying rapid increase in the surface tension. This increase in surface tension is reflected in a tendency for the liquid to pull itself into drops, to minimize the surface area of the low-ethanol content surface film of the liquid.

Adamson, A. W., *The Physical Chemistry of Surfaces*, John Wiley & Sons, New York.

Bhatacharjee, J. K., "Marangoni Convection in Binary Liquids," *Physical Review E*, 50 (1994), 2, 1198–1205.

A similar shot appeared on the cover of Langmuir, *October 1995. The work was done in the laboratory of Professor Mark Wrighton, former Provost of MIT, and now Chancellor of Washington University, St. Louis. Mi, N*

Tatistcheff, H. B., I. Frisch-Faules, and M. S. Wrighton, "Comparison of Diffusion Constants of Electroactive Species in Aqueous Fluid Electrolytes and Polyacrylate Gels: Step Generation-Collection Diffusion Measurements and Operation of Electrochemical Devices," *Journal of Physical Chemistry*, 97 (1993), 2732–39.

Frank Mowery, head of conservation at the Folger Shakespeare Library in Washington, D.C., introduced me to the library's glorious Shakespeare collection. This signature is one of very few in the world. I used the 105 mm lens on a copy stand. Ma

The book from which this signature was taken is *Archaionomia* ("Ancient Laws" in Greek) printed in London in 1568 and found in the Folger Shakespeare Library in Washington, D.C. It is a text of old English laws accompanied by Latin translations by William Lambard. Mowery believes that the signature is authentic because it was found before the earliest of the known signatures, resembles it, and is known to have been written long before the time of the notorious Shakespeare forger William Henry Ireland. Mowery believes that, if genuine, this signature may suggest that Shakespeare had studied as a law clerk under Lambard. Shakespeare might have been given this book by the author.

Langwell, W. H., *The Conservation of Books and Documents*, Greenwood Press, Westport (1974).

Plenderleith, H. J., *The Conservation of Antiquities and Works of Art: Treatment, Repair and Restoration*, 2nd ed., Oxford University Press, London (1971).

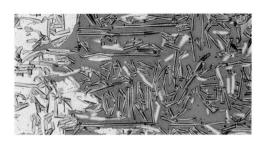

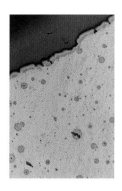

Rust

This is a wonderful old farm implement. I shot the square hole with a 105 mm lens.

Atkins, P. W., *The Second Law*, Scientific American Books, W. H. Freeman and Co., New York (1984).

Fenn, J. B., *Engines, Energy, and Entropy*, W. H. Freeman and Co., New York (1982).

Smith, E. B., *"Basic Chemical Thermodynamics,"* 4th ed., Oxford Science Publications, Clarendon Press, Oxford (1993).

Mechanical Failure of a Thin Film

Errors can be interesting, and this one produced a remarkable consistency in the size of the peeled film cylinders. This observation led me to ask more questions about fracturing. Mi, N

The method used here is called "molecular layer dosing." The failure in this experiment was an artifact of the conditions used; the procedure is normally reliable.

Ehrlich, D. J., and J. Melngailis, "Fast Room-Temperature Growth of SiO_2 films by Molecular Layer Dosing," *Applied Physics Letters*, 58 (1991), 2675.

Electrical Damage in a Light-Emitting Display

Brian Cumpston, a graduate student working in Klavs Jensen's lab at MIT's Department of Chemical Engineering, was designing LED displays using polymers. The unwanted oxidation of the material produces interesting patterns.

Burrows, P. E., et al., "Reliability and Degradation of Organic Light-Emitting Devices," *Applied Physics Letters*, 65 (1994), 2922–24.

Scott, J. C., et al., "Degradation and Failure of MEH-PPV Light-Emitting Diodes," *Journal of Applied Physics*, 79 (1996), 2745–51.

Yam, P., "Plastics Get Wired," *Scientific American*, 273, 1 (1995), 74–79.

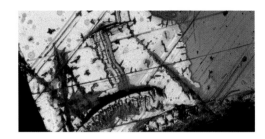

Columns with Lichen

Damaged Film

Oxide Layer
on a Copper Pan

Lichen grew on just one side of the columns on one of the structures at Stourhead. Professor Donald Pfeister, director of the Harvard University Herbaria, confirmed that I had, in fact, photographed lichen.

Here are more errors. Some interesting colors are produced with the help of Nomarski because of the surface structures. Mi, N

A friend let me borrow this magnificent au gratin dish. I shot its oxidized underside using daylight with the 105 mm lens.

The lichens attacking these columns are several species of crustose lichens. Crustose is a type of lichen thallus that attaches firmly to the surface of the substrate.

Barinaga, M., "Origins of Lichen Fungi Explored," *Science*, 268 (1995), 5216, 1437.

Kiester, E., "Prophets of Gloom," *Discover*, 12 (1991), 9, 52-56.

Monastersky, R., "The Endiacaran Enigma: Were the Oldest Animals Actually Lichens?" *Science News*, 148 (1995), 2, 28–30.

Burrows, P. E., et al., "Reliability and Degradation of Organic Light-Emitting Devices," *Applied Physics Letters*, 65 (1994), 2922–24.

Scott, J. C., et al., "Degradation and Failure of MEH-PPV Light-Emitting Diodes," *Journal of Applied Physics*, 79 (1996), 2745–51.

Frumhold, Jr., A. T., *Theory of Metal Oxidation*, North Holland Publishing Co., New York (1975).

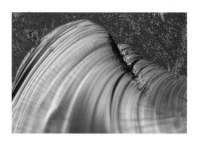

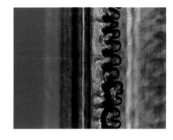

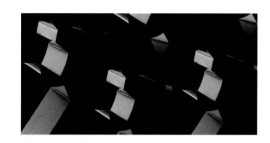

Surface of Broken Glass

One of my undergraduate photography students at MIT, Katherine Notter, took a wonderful picture of a piece of broken glass, and I thought I'd give it a try. Mi, N

Fracture mechanics is the study of the mechanisms of failure of solids. The wide range of failure mechanisms includes not only cracking but also solids flowing, slipping along planes in crystal, or generating bubbles by cavitation ahead of the crack tip. Glass is a brittle solid and fails by concoidal fracture in a series of progressive fractures of the silicon-oxygen and boron-oxygen bonds that make up the glass, interspersed with pauses while the tension builds to levels that permit the fracture tip to advance.

This picture was taken using reflection Nomarski-mode photomicrography, and the colors provide a map of the topography of the surface. Reflection Nomarski mode records lateral gradients in the phase of the light that correspond to gradients in height.

Hartman, J. S., R. L. Gordon, and D. L. Lessor, "Quantitative Surface Topography Determination by Nomarski Reflection Microscopy. 2: Microscope Modification, Calibration, and Planar Sample Experiments," *Applied Optics,* 19 (1980), 2998–3009.

Marder, M., "Energetic Developments in Fracture," *Nature,* 381 (1996), 275–76.

Failure in Adhesion

Professor Manoj Chaudhury and graduate student Bi-Min Zhang Newby from the Department of Chemical Engineering at Lehigh University sent me some samples of surfaces. As they suggested, I stuck some clear tape on one, slowly pulled it away, and observed the adhesion changes at the interface of the adhesive and the surface under the microscope as it was being pulled. Mi, N

A pressure sensitive adhesive like 3M's Scotch tape is a viscoelastic polymer. Any elastic deformation within the adhesive is resisted by its high viscosity. When the adhesive is peeled from a solid surface, competition between applied pressure and surface tension in the viscous polymer leads to an instability of the miniscus that grows into waves and well-developed fingering patterns whose shape and size depend upon the interaction of the adhesive with the substrate.

Fields, R. J., and M. F. Ashby, "Finger-like Crack Growth in Solids and Liquids," *Philosophical Magazine,* 33 (1976), 33–48.

Newby, B. Z., M. K. Chaudhury, and H. R. Brown, "Macroscopic Evidence of the Effect of Interfacial Slippage on Adhesion," *Science,* 269 (1995), 1407–09.

Urahama, Y., "Effect of Peel Load on Stringiness Phenomena and Peel Speed on Pressure Sensitive Adhesive Tape," *Journal of Adhesion,* 31 (1989), 47–58.

Prismatic Soap Bubbles

James Ossi calls himself a gismologist. He specializes in creating bubble machines. This one sits in the physics department lobby at MIT, and I am always mesmerized when I pass by it. I pushed Velvia film a full stop for this three image composite. The bubbles were continuously moving, and I needed the faster shutter speed. I shot with a 55 mm lens through the glass. Ma

Lipid films are widely used as models for self-assembling structures: that is, structures in which complex macroscopic and molecular orders arise spontaneously from the shapes of the molecules and the forces between them. These structures are among the simplest of those used to test theories of self-assembly. They are directly relevant to biologically important self-assembling structures such as cell membrane. They are related structurally to thin (as thin as monomolecular) films of organic molecules formed on surfaces by detergents, adhesion promoters, and friction and corrosion-protection agents.

Isenberg, C., *The Science of Soap Films and Soap Bubbles,* Dover Publications, New York (1978).

Lovett, D., *Demonstrating Science with Soap Films,* Institute of Physics Publishing, Bristol, U.K. (1994).

155

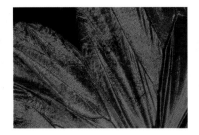

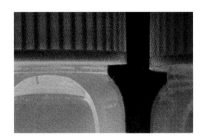

Wing of a Morpho Butterfly

I photographed M. sulkowski, from Brazil, in daylight. Ma

Dushkin, C. D., et al., "Colored Multilayers from Transparent Submicrometer Spheres," *Langmuir*, 9 (1993), 12, 3695–701.

Heilman, B., and I. N. Miaoulis, "Insect Thin Films as Solar Collectors," *Applied Optics*, 33 (1994), 28, 6642–47.

Lewis, H., *Butterflies of the World*, Follett Publishing Co., Chicago (1973).

Peterson, I., "Butterfly Blue: Packaging a Butterfly's Iridescent Sheen," *Science News*, 148 (1995), 296–97.

Colors from Transparent Spheres

Professor Kuniaki Nagayama at the University of Tokyo in the Department of Life Sciences sent me various samples from his lab in Japan. The green image, taken with a stereomicroscope, was shot with reflected tungsten light. The large brown and purple microscopic image was taken with reflected light, using Nomarski. SM (green image); Mi, N (brown and purple image).

The preparation of uniformly sized polymer microspheres is usually carried out by emulsion polymerization. The polymerization is initiated simultaneously thermally or photo-chemically, and the rate of growth of polymer becomes mass-transport-limited under appropriate conditions: under these circumstances, the length of the polymer chain and the mass of polymer are independent of the size of the original droplet.

Forming ordered monolayers of these colloids is an art. Here, the microspheres deposited on a surface from a liquid that was being withdrawn; the gentle wiping action of the retreating liquid drop compacted the microspheres and allowed them to crystallize.

Yamaki, M., et al., "Size-Dependent Separation of Colloidal Particles in Two-Dimensional Convective Self-Assembly," *Langmuir*, 11 (1995), 2975.

Dots on Paper

I photographed a published image of the suspensions of fluorescent particles (see page 23) from a Technology Review *article, May/June 1996. SM*

Eckstein, H. W., *Color in the 21st Century: A Practical Guide for Graphic Designers, Photographers, Printers, Separators, and Anyone Involved in Color Printing*, Watson-Guptill Publications, New York (1991).

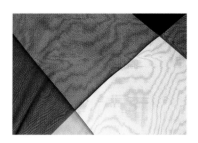

Hologram

Artist Betsy Connors of Somerville, Massachusetts, used holography to create an environmental piece called Light Forest, a Holographic Rainforest, *at the MIT Museum. It is impossible to capture the three-dimensional quality of a hologram in two dimensions, so I focused in on the plastic surface detail. The granulated effect is the scattering of the light.*

A hologram replicates the pattern of light in space that would be generated by a three-dimensional object. Most techniques for storing information holographically rely on interference between a reference source of light and light from the storage medium that contains the information. This medium is an analog of a diffraction grating, storing information about the amplitude and phase of the light relative to the reference beam. This information can be recorded as a reflective surface on a sheet of plastic, or as variations in the index of refraction in a three-dimensional solid.

Calfield, H. J., "Holograms," *National Geographic,* 165 (1984), 3, 364–77.

Kasper, J. K., and S. A. Feller, *The Complete Book of Holograms,* John Wiley & Sons, New York (1987).

Saxby, G., *Practical Holography,* 2nd ed., Prentice Hall, New York (1994).

Engineering Light

Dr. John Rogers in the Whitesides lab created a pattern to demonstrate how surface structure can affect laser output. These seven images were digitally composed. I photographed each one off a white card, using a 105 mm lens. C

An elastomeric phase grating was fabricated from PDMS with a surface relief consisting of an approximately 2 μm square-wave pattern. The optical path of light could be changed by compressing the grating using a glass rod. The index of refraction of air is 1.0; that of PDMS is approximately 1.5. Thus, a compression of approximately a μm was sufficient to change the phase angle from 360˚ to 180˚, and to change the grating from one that transmitted almost 100% of the light in the zeroth order spot to one in which almost 80% of the light appeared in the first order diffraction spots. This image is a composite of seven vertical exposures. In the last six, the glass rod compressed different points on the surface.

Rogers, J. A., et al., "Elastomeric Binary Phase Gratings for Measuring Acceleration, Displacement, Strain, and Stress," *Review of Scientific Instruments,* in press.

Rogers, J. A., et al., "Elastomeric Diffraction Gratings as Photothermal Detectors," *Applied Optics,* in press.

Moiré Pattern

Draping and overlapping a few loosely woven fabrics and attaching them to my window during the day created some interesting moiré patterns.

Kinneging, A. J., "Demonstrating the Optical Principles of Bragg's Law with Moiré Patterns," *Journal of Chemical Education,* 70 (1993), 6, 451–53.

Liu, S., "Artistic Effect and Application of Moiré Patterns in Security Holograms," *Applied Optics,* 34 (1995), 22, 4700–702.

Mauvoisin, G., F. Bremand, and A. Lagarde, "Three-Dimensional Shape Reconstruction by Phase-Shifting Shadow Moiré," *Applied Optics,* 33 (1994), 11, 2163–69.

The Shape of a Molecule

This is not a photograph but a digital contour map of a protein structure. Research associate Brian Sheehan in Dr. Mark Yeager's lab at the Scripps Research Institute, Department of Cell Biology, sent the black and white version over the Internet. I tinted it using Adobe Photoshop.

This image is a projection electron-density map of a cardiac gap junction membrane channel. It was obtained by low-temperature electron microscopy and digital image processing. The continuous contours in the map correspond to electron density. The channel is about 6.5 nm in diameter and is formed by a circular cluster of six protein molecules. Ionic flow through the central pore of the channel allows propagation of electrical current between heart cells. These channels therefore play a critical role in maintaining the normal heartbeat, and important insights into pathological heart rhythm disturbances, or arrhythmias, can be gained by knowing their molecular structure.

Creighton, T. E., *Proteins, Structures and Molecular Properties,* 2nd ed., W. H. Freeman and Co., New York (1993).

Glusker, J. P., and K. N. Trueblood, *Crystal Structure Analysis*, Oxford University Press, Oxford (1985).

acknowledgments

This book describes many individuals' work. Without their help in obtaining the images and understanding the objectives of the research, we could not have proceeded. In the "Notes and Readings" section, we acknowledge the individuals with whom we worked most closely; here, we thank all of them collectively for making the science that we describe happen: this book celebrates their accomplishments. We note the obvious: that the understanding of nature grows through many contributions over many years, and in praising explicitly a few of those now involved in the process, we also mean to salute their colleagues, coworkers, competitors, and forebears.

The John Simon Guggenheim Memorial Foundation supported the photography; without this support, there would have been no book.

Finished prose is a collaboration between writer and editor. We have been most fortunate in this work in having two editors—Jisho Cary Warner and Barbara Whitesides—each with an affinity for clarity, an ear for tone, and an instinct for science. The book would be different and much the poorer had they not taken it in hand. Others have also helped. Among them we especially thank Nick Abbott, Mary Cattani, Lois Craig, Ken, Matthew, and Michael Frankel, Greer Gilman, Nancy Kopell, Virginia Loo, Anne-Marie Michel, Christina Platt, John Rogers, James Shapiro, Elizabeth Thomson, Giselle Weiss, and Ben and George Whitesides.

Caroline Herter and Emily Miller at Chronicle Books helped to shape the balance, style, and form of the book, and gathered up the missing threads after deadlines. Their enthusiasm for the project helped to start and sustain it. Stuart McKee and Jill Jacobson integrated the images and the text. Neal Goldman guided the necessary preliminary legal agreements. Part of the book was written during a tenure as the Lord Todd visiting professor of chemistry at Cambridge University.

Our colleagues at MIT and Harvard built the intellectual community in which we lived while working on this project. They have taught us most of what we know of science and technology.

index of entries